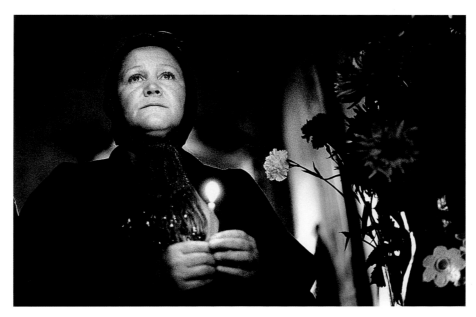

Banned for over 40 years, this was one of the first services to be held
at the main Ukrainian Orthodox Church in Kiev, re-opened in 1991.

First published in the United Kingdom in 1998 by
Dewi Lewis Publishing
8 Broomfield Road, Heaton Moor, Stockport SK4 4ND, England
in association with Bradford Heritage Recording Unit, British Library National Sound Archive and University of Sheffield

All rights reserved
ISBN: 1 899235 56 6

Copyright ©1998

For the photographs: Tim Smith, BHRU, David King Collection, Ukrainian State Archives
For the texts: BHRU, British Library National Sound Archive, University of Sheffield

Extracts from interviews were not necessarily said by the people who appear in the photographs that accompany them.
Ukrainian place-names have been used throughout, using the book 'Ukraine, a history' by Orest Subtelny as a reference for spelling.

The authors would like to acknowledge the following:

The invaluable research work of the late Dr Clare Evans, who began work on this project but was forced to leave her post due to ill health.

In Ukraine and Russia
For advice and inspiration: Andrei Ivankiv, Victor Susak, Nikolai Danilov. For help and hospitality: Sergei Ksenofontov, Tatyana Ksenofontova, Irina Baskacova, Natali Shimanskaye (Kiev Memorial), Lydia Vsevolodnovna (Odessa Memorial), Valery Stepanenko, Peter Bikovsky (Donetsk), Ihor Hyrch, Alexei and Galina Unanovna (Kiev), and Petro Beimuk (Stryi). For translations: Inna Chernyavskaya (Odessa), Marianne Romina and Yuliana Perun (Lviv), Vera Hyrch (Kiev), and Alexander Tumanov (Donetsk).

In Britain
For funding: The City of Bradford Centenary, The Winston Churchill Memorial Trust, the Migration & Ethnicity Research Centre at the University of Sheffield, the Leverhulme Trust, and Photo '98. For help, advice, and translations: Wolodymyr Demtschuk, Teresa Cherfas, Jon Cohen, Irene Diakiw, Genia Mandzij, Roxalana Rutkowskyj, Bohdan Sweryt, Vera Smereka, and members of the Federation of Ukrainians and The Association of Ukrainians in Great Britain. For editorial assistance: Janet Collopy. For the use of photographs and documents: David King, Oleksa and Andrew Semenuik, Mykola Kazybrid and John Piper. For advice and support: Peter Jackson, Colin Holmes, Ken Roberts and Jane Tyrtania.

SPONSORED BY

MARKS & SPENCER

Ukraine's Forbidden History

tim smith
rob perks
graham smith

in association with
Bradford Heritage Recording Unit
British Library National Sound Archive
University of Sheffield

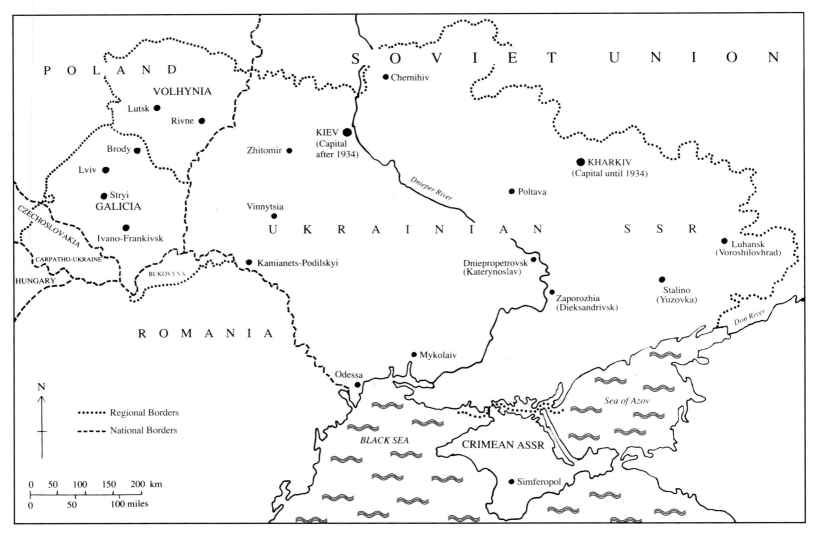

POLAND

VOLHYNIA

Lutsk ●

Rivne ●

Brody ●

Lviv ●

Stryi ●

GALICIA

Ivano-Frankivsk ●

CZECHOSLOVAKIA

CARPATHO-UKRAINE

HUNGARY

BUKOVYNA

Kamianets-Podilskyi ●

ROMANIA

Zhitomir ●

Vinnytsia ●

U K R A I N I A N

KIEV ●
(Capital
after 1934)

Chernihiv ●

S O V I E T U N I O N

Dnieper River

● KHARKIV
(Capital until 1934)

Poltava ●

S S R

Dniepropetrovsk ●
(Katerynoslav)

Zaporozhia ●
(Dieksandrivsk)

Stalino ●
(Yuzovka)

● Luhansk
(Voroshilovhrad)

Don River

Mykolaiv ●

Odessa ●

BLACK SEA

Sea of Azov

CRIMEAN ASSR

Simferopol ●

N

····· Regional Borders
- - - National Borders

0 50 100 150 200 km

0 50 100 miles

Soviet Ukraine during the
interwar period.

INTRODUCTION

Ukraine's declaration of independence on 24 August 1991 created the largest new state in Europe this century and precipitated the final collapse of the Soviet Union. With independence people began to speak openly and publicly about how they had lived during decades of repression. From Lviv in the rural west to Donetsk in the industrial heartland of the east, people gave voice to memories and experiences hitherto only spoken of to family and close friends, if at all. For three generations Ukrainians had carried their experiences inside them, afraid to remember. But as organisations such as Memorial, set up to commemorate the victims of Stalin's repression, began to investigate the mass graves of his victims, oral testimonies acquired a vital role in retrieving and rescuing a history that had been denied and forbidden.

In Ukraine the memories of older people, by emphasising a sense of common struggle and national consciousness, have contributed to a process that has forged a new Ukrainian identity where one had scarcely existed before. 'Ukraine' means 'borderland' and the lack of natural boundaries and physical obstacles has given the region a chequered and complex history. Within living memory, parts of what is now Ukraine have been Polish, Romanian, Czech, Austro-Hungarian, Byelorussian, German, Russian and Soviet. People born in Poland, who have spent most of their lives in the Soviet Union, now live in Ukraine, without ever moving from the street in which they were born. The past century has also been a brutal one: Polish, German and Soviet occupation of Ukraine demanded a huge price in human lives. Between 1930 and 1945 alone, approximately fifteen million people, over a quarter of Ukraine's population, died as a result of famine, mass execution, war and nationalist struggle. Typical of many of the older people in this book, Amelia Dudar of Lviv lived through two world wars, a revolution, a civil war, three famines, violent occupation by four armies, and ten years' imprisonment in Siberian workcamps.

In the autumn of 1991 Rob Perks (Curator of Oral History at The British Library National Sound Archive) and Tim Smith (photographer for Bradford Heritage Recording Unit – BHRU) visited Ukraine to interview and photograph people at a pivotal moment in their history. Travelling extensively from Donetsk to the Crimea, from Odessa to Kiev, from Zhitomir to Lviv and into the Carpathian mountains in the west, we set out to record the remarkable experiences of the last of the pre-Revolution generation, of those who had suffered the repressions and famine of the interwar period, and to talk to people about their ideas of what an independent Ukraine might be.

It was by no means a straightforward task: on a practical level we met with official opposition, a chaotic transport system and serious shortages. People in the main cities, such as Kiev and Lviv, were confident enough to talk frankly and be photographed. But in the Russified east of the country and in rural areas many people were still afraid of speaking openly about their experiences. In Barushkovtsi, a remote village in the Zhitomir region, we found Soviet-style politics still reigned. It was last visited by Westerners when the retreating German army razed it to the ground in 1944 and our arrival was met with a wall of stony silence. The one woman who did agree to talk to us shook with fear throughout the interview and asked that she remain anonymous. Her views were unreconstructed Soviet Communism. In another area villagers were reluctant to disrupt a close-knit community which had come uneasily to terms with its past. Slavsko, in the Carpathian mountains near the Romanian border, was the regional base for the Soviet secret police. Their victims were buried in mass graves in the centre of the village, and excavation work by Memorial was cold-shouldered by most local people. Some of the executioners were still living in the village, and were pointed out to us as they trundled past on their carts. We began to realise that it is almost impossible for outsiders to imagine what life had been

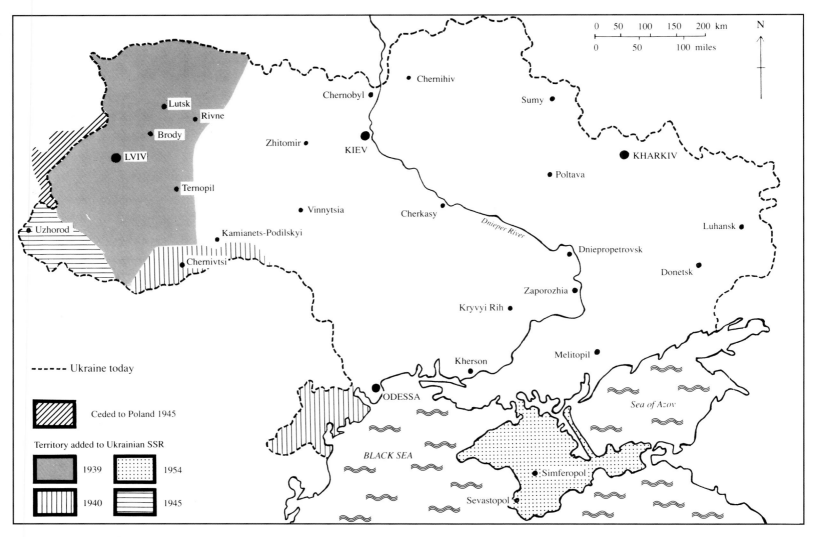

Territorial gains of Soviet
Ukraine, 1939-54.

like in a totalitarian society, and it was often difficult to ask the right questions. People would say: 'You would not ask such a question if you had lived in the Soviet Union. It was because it was. It happened because it happened. You did not ask questions.'

Although the events of 1991 were the spur for this book, its origins date back to the early 1980s, when the imminent break-up of the Soviet Union seemed inconceivable. As many as 2.5 million people who describe themselves as Ukrainians live outside their homeland and form expatriate communities around the world. These communities – the 'diaspora' – traditionally saw their role as guardians of Ukrainian language, culture and history during the decades of Soviet repression in Ukraine. In 1983 the BHRU began an oral history interviewing programme in northern England, which is home to the largest expatriate communities of Ukrainians in Western Europe. Researchers tape-recorded the life stories, memories and reflections of three generations of Ukrainians, and archived copies of their photographs and documents. The first generation, who had mostly arrived in Britain in the late 1940s, spoke of their youth in the homeland and how they had built their communities in exile into a 'little Ukraine'. At that time many spoke guardedly for fear of repercussions against family still in the Soviet Union, but most spoke too of their dreams for the future, of a free and independent Ukraine to which one day they might return.

Since independence this work has been extended by the Migration and Ethnicity Research Centre at the University of Sheffield, initially by Clare Evans. The impact of Ukraine's independence on the diaspora has been immense. Older Ukrainians, many of whom were forced to leave their country and have spent over fifty years in exile, find their memories and ideas of their homeland difficult to reconcile with modern-day Ukraine. Amongst the younger generations there has been a re-examination of what it means to be Ukrainian. The Centre's oral history project, conducted by Graham Smith, has explored changing identities amongst

Ukrainians in Britain. One important result is a greater appreciation of the complexity of the memories of members of the diaspora and the history of Ukraine.

In 1997 Tim Smith returned to Ukraine and worked closely with Victor Susak, Research Associate in the Institute for Historical Research at Lviv State University, to explore how the high expectations of 1991 had been translated into the reality of an independent nation. The bulk of the KGB's archives remain closed, and many former Party members who imprisoned the nationalists have now borrowed their slogans and stay in power. But we had access to the Ukrainian State Archives and many of their photographs reproduced here have never previously been seen in the West.

The oral testimonies collected in Britain and Ukraine, and presented in this book, reflect the developing relationship between diaspora and homeland. Although few of the older generation have returned on a permanent basis there are younger members of the diaspora who have returned to live and work in the country. Brought up to dream about an independent Ukraine full of fervently nationalistic and religious people, they arrived to find a new nation whose citizens are struggling to make ends meet. Independence has been accompanied by problems common to all countries emerging from the old Soviet empire. People have had to contend with industrial and agricultural collapse, food shortages, rampant inflation, unemployment and crime. The country is also trying to make sense of itself as a new nation, pluralistic but conscious of its own history and identity. Many now speak of independence as the beginning of this process rather than the end.

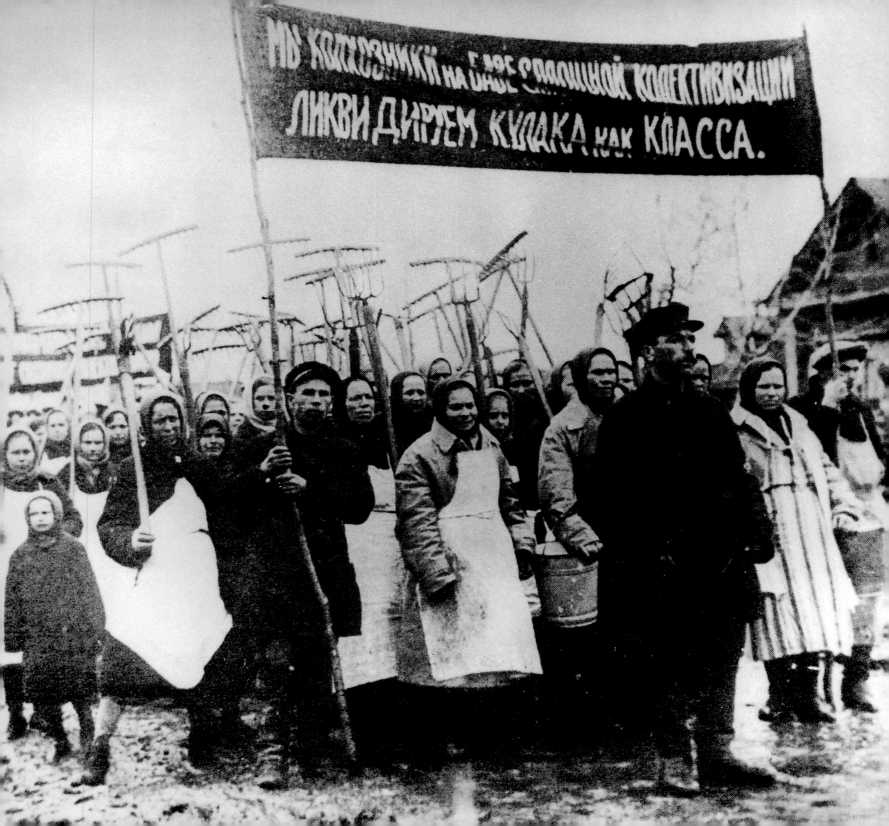

REPRESSION AND TERROR: THE 1920s AND 1930s

Ukraine emerged from the First World War just as divided and dismembered as it had entered it. Ukrainians fought on both sides of the conflict, for both the Austrian and Russian imperial armies, suffering huge losses. Immediately following the Russian Revolution of October 1917, a Ukrainian People's Republic had been proclaimed which clashed with Red Army troops before they were distracted by the short-lived German occupation of Ukraine in March 1918. Over the next two years of chaotic armed struggle, eight different regimes governed Ukraine or parts of it, including the Bolsheviks' Red Army, Petliura's Nationalists, Denikin's White Army and Makhno's Anarchists. Both Symon Petliura and the legendary Nestor Makhno proved popular amongst the Ukrainian peasantry. In the end, Western Ukraine, totalling around 7 million people – overwhelmingly small-holding peasants – was divided. Poland absorbed Galicia, including a significant number of Jewish communities already decimated by the pogroms of 1919-20, which had left between 35,000 and 50,000 Ukrainian Jews dead. Romania took Bukovina, and Czechoslovakia was left with Transcarpathia. The bulk of Ukraine, some 23 million people, became the Ukrainian Soviet Socialist Republic, ruled directly from Moscow.

Both Poland and Romania pursued aggressive policies of assimilation, reworking and renaming administrative units, dismantling the Ukrainian school system, redistributing land to Polish and Romanian colonists, and destroying orthodox churches. In Polish Ukraine, the Ukrainian National Democratic Alliance (UNDO) was formed in 1925 to advocate Ukrainian autonomy through the Polish *diet* (parliament) but had limited success, and in 1929 the radical right-wing Organisation of Ukrainian Nationalists (OUN) was established, led by Evhan Konovalets. During the 1930s OUN pursued a controversial campaign of assassinations and sabotage attacks on Polish officials and property. This led to policy disagreements and eventually a schism in OUN

between two factions: OUN-M led by moderate Andrii Melnyk, and OUN-B led by the dynamic young Galician radical, Stepan Bandera, who favoured more violent direct action. A ferocious antagonism developed between the two which was later evident amongst the Ukrainian diaspora and had far-reaching consequences long after the Second World War. In the short term the ideas of Adolf Hitler and the Nazi concept of ein Volk, ein Reich, fiercely anti-Communist and anti-Russian, became ideologically popular amongst the young followers of Bandera in Western Ukraine, pursuing the single aim of a Ukrainian nation-state. Evidence has also recently emerged that OUN-B maintained close relations with the Nazi Gestapo both before and after the outbreak of war.

For those Ukrainians in the Eastern part of Ukraine, life under Soviet power was ultimately much worse than that under Polish and Romanian rule. Initially the ruling Ukrainian Communists were permitted to pursue a policy of Ukrainian autonomy, and the 1920s were an extraordinarily rich period for the flowering of Ukrainian culture and a decisive phase in the creation of modern Ukraine. Ukrainian language teaching was encouraged and Ukrainian literature and history flourished. This was all the more remarkable because this was a period when the notorious Lazar Kaganovich, himself a Ukrainian Jew, was First Secretary of the Communist Party of Ukraine (CPU). Kaganovich was later to acquire a fearful reputation as one of Stalin's closest, most hated henchman.

Ominously, this initial period of modest 'Ukrainian-isation' was short-lived. It provoked resentment amongst the large numbers of Russians, Jews and other ethnic groups living in Ukraine; and when the new nationalistic confidence began to take on an anti-Russian flavour it was dubbed 'an agent of imperialism'. Under Stalin's direction, and later under Khrushchev as First Secretary of the CPU, there was a process of Russification. Russian

quidate the
aks as a class'
ds the banner,
slogan adopted
Stalin as
lectivisation
s enforced
oughout
viet Ukraine.

vid King Collection

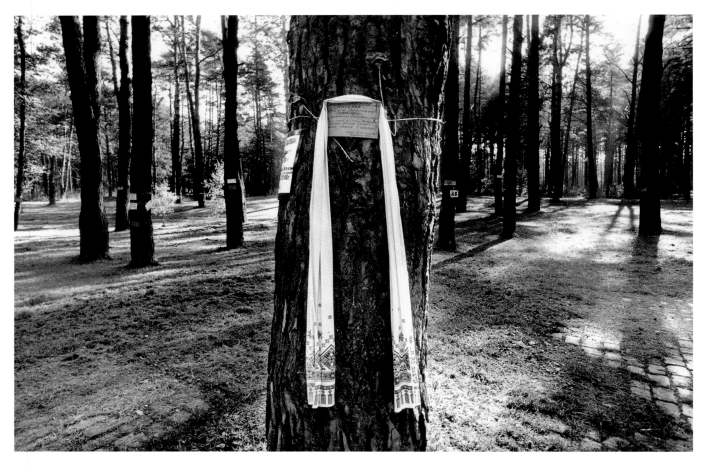

Surrounded by a high fence, Bykivnya forest on the outskirts of Kiev served as a vast burial ground for the NKVD. In 1988 the authorities still maintained that any bodies found in the forest were victims of the Second World War, and erected a monument to the victims of fascism. Only of late has the true story emerged.

"Everyone who had their own opinion about life, it didn't matter who they were, maybe a writer or a worker or a member of the collective farm – they were repressed here . . . They shot them in Kiev. We estimate that there are about 200,000 lying there but the KGB archives have, we think, been destroyed. The witnesses said that in this forest the lorries began to bring bodies as early as 1929. These were isolated incidences when soldiers would come at night, dump the bodies and cover them up. It was in 1936 when the repressions became more severe that they began to bring lorry loads here and they started a whole enterprise for the killing . . . Everyone knew that these were bodies that had been shot before the war, but they only spoke about it quietly as they were afraid . . . For a long time people wondered and we looked and guessed, then in the 60s people began to talk about this place. Then in the 80s the situation became more apparent. I come here every year. My grandfather lies here. He was shot in Kiev in 1936. Everyone knows someone here . . . At the beginning of every May people come and hold a meeting to the memory of those who were shot here. This year [1991] we announced that everybody who had lost a member of their family should come and place a piece of paper on the trees to announce they had lost someone here."

language teaching became compulsory; Russian party officials were brought in to replace Ukrainians; the press were emasculated; and an anti-religious campaign led to the widespread arrest of village priests and the closure of churches.

Concurrently a campaign was begun in 1929 to force peasants to give up their own land and join collective farms, or kolkhoz. Intellectuals and those peasants deemed to be wealthier were labelled kulaks and either shot or deported to labour camps in Siberia or the Urals, where many died. The same fate befell anyone who refused to join the kolkhoz, as the slogans of the day reflected: 'Those who do not join the kolkhoz are enemies of soviet power. The heroic period of our socialist construction has arrived. The kulaks must be liquidated'.

Whether or not collectivisation was applied more determinedly in some areas than others, as part of an explicit policy by Stalin to crush nationalist and ethnic opposition throughout the Soviet Union, it is nonetheless estimated that ten million people were deported, of whom three million perished. Agricultural collectivisation destroyed the entire structure of Ukrainian village life and the land tenure system, exiled leading farmers and led to a disastrous collapse in agricultural production. With enforced collectivisation came, at first, unachievable crop quotas (despite plummeting yields and abysmal harvests), and later the ruthless requisitioning of livestock, grain and crops by the Soviet security police, the NKVD (also known as the GPU, a predecessor of the KGB). This resulted in the Great Famine in Ukraine and in the Ukrainian-speaking area of the Kuban in the North Caucasus, in 1932-3, when as many as seven million people starved to death. Many more died than in the earlier famine of 1921-2 and on this occasion the government went to extreme lengths to keep it secret, both from the foreign press and even from Ukrainians in the major cities. Road blocks were set up to prevent the movement of starving peasants, and visiting dignitaries, such as British socialists Sidney and Beatrice Webb and George

Bernard Shaw, were shown fictional kolkhoz of well-fed and happy workers. Only in recent years have some of the survivors of the Famine begun to reveal the true story of loss.

Hard on the heels of the famine came the Great Terror, a massive purge of every level of Soviet society in which people were randomly arrested and deported or summarily executed without trial, often for no reason other than personal jealousy. A form of collective madness swept Ukraine. This was a period when family members, friends and neighbours disappeared overnight without explanation; when children informed on their parents for 'anti-revolutionary behaviour'; when Ukrainian writers and artists were arrested and subjected to show trials. Some, like one of Ukraine's best-known writers, Nicholas Khvylovy, committed suicide before he could be tried. Sixteen Ukrainian poets, starting with Vlyko in 1934, are named as having been executed or dying in the gulags of Solovetsk and Kolyma before 1942. And in January 1936 another group of poets were tried in Kiev and executed for 'nationalism, terrorism and espionage'.

By 1938, as a result of Stalin's Terror, only three out of 115 committee members of the Communist Party of Ukraine elected in 1934 were still alive, and in May and June of that year the entire government of Ukraine was executed. For a time so few people in authority remained that no-one seemed to know who was in charge. The continuity of rule was completely obliterated. Between 1935 and 1941 the NKVD arrested 19 million Soviet people of whom 7 million were executed or died: at least a million were Ukrainians. Until the early 1990s the whereabouts of many of the victims' bodies was unknown, but excavations by voluntary organisations such as Memorial, guided by the oral testimony of survivors, have uncovered secret mass graves, often close to major cities, such as Bikivnyna near Kiev.

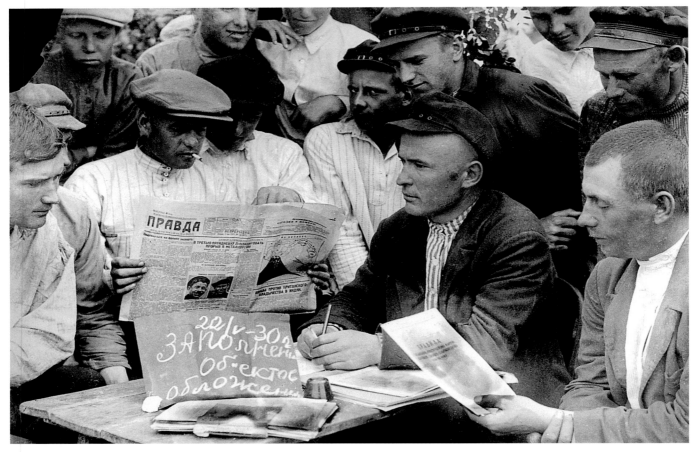

Representative of the regional Communist Party explaining the collectivisation and agricultural taxing policy to peasants in the town of Gryshyno, May 22nd, 1930.

Ukrainian State Archives

"Collectivisation began in 1929. The party representatives visited every house and if the family refused to join the Kolkhoz they were deprived of their property and sent to Siberia. They took our cow even though we were eleven children in our family – little ones – and my mother knelt down and begged the activists. About thirty families from our village were sent to Siberia. Some families which didn't want to join the kolkhoz were taken out of the village and thrown naked into the snow, and they froze to death."

Meeting of tractor
drivers in the town of
Stalino, now known
as Donetsk, during
the collectivisation of
Eastern Ukraine, 1934.

Ukrainian State Archives

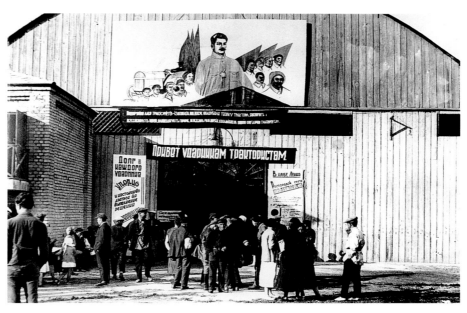

"By 1931 everyone was in the kolkhoz.
Everyone worked hard but didn't get a salary,
only credits in a book. The starvation began in
the autumn of 1931: absolutely everything was
taken out of the village. They came to every
house to search for bread. If anyone tried to
hide grain they took long poles and searched
under the ground. People were hungry and they
died. Laughter disappeared from the village. In
spring 1932 people had to eat plants; there
were no vegetables, no food at all, we had to
eat leaves from the trees. 1933 was the worst:
my whole family died. Only me and my little
brother survived. It was a terrible time, terrible."

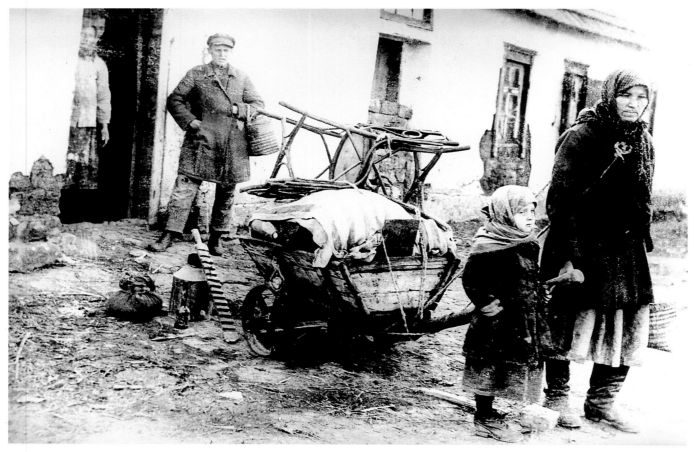

A Kulak family are forced to leave their home in the village of Udachanoya, near Donetsk, as part of Stalin's policy of collectivisation, circa 1930.

Ukrainian State Archives

"Stalin took everything from the people. The result was starvation – people were falling in the street. It is too sad to talk about. By 1933 all was gone and people were forced to go to the collective farm. They took everything. My sister was asking my mother for something to eat, but there was no milk or bread. My sister wanted to eat her hands, so my mother tied her hands to her side."

"I remember my little brother and sister, the first word that they pronounced was not 'mother', but 'give, give, give' all the time. They faded very quickly. People began to eat people. There was a little church in our village and dead bodies were taken to it. When they came to take them to the cemetery they saw that some people had cut off a hand, a piece of the body, in order not to die from hunger."

All food produced
on the collective
farms was collected
together for
redistribution, as
shown here
in Bedny,
near Donetsk.

Ukrainian State Archives

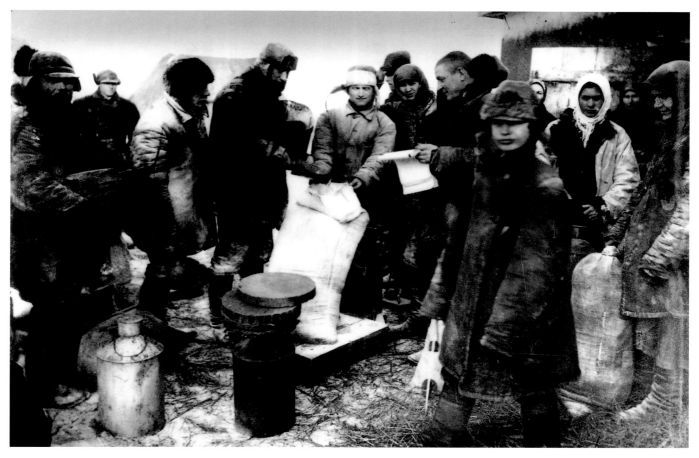

"My auntie buried potatoes in a trunk under her house. When she died my mother went to clear the house and found the potatoes. She planted bits of them in the field and we ate the rest. So we managed. We made soup from the leaves of the cherry tree, and ate grass that wasn't poison. One thousand died out of a village of two thousand. My sister and father died."

"There were attempts to leave but there were soldiers on all Ukraine's borders; it was impossible to get out. They killed everyone who attempted to go to other republics. In our village 3,000 people died, compared to 185 who died later in the war."

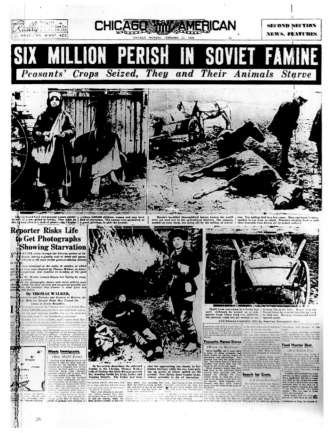

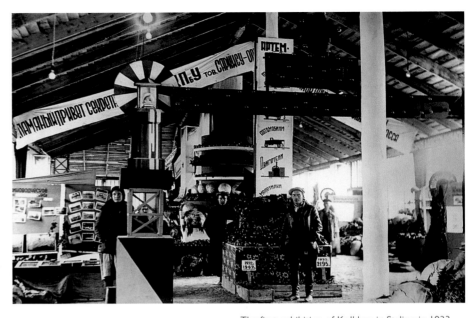

Press report in
American newspaper
documenting the
enforced famine in
Eastern Ukraine, 1935.

Ukrainian State Archives

The first exhibition of Kolkhoz in Stalino in 1933.
Such displays were held not only to persuade local
people of the success of the collectivisation policies,
but were also used to convince overseas visitors. The
second quotation below is from a letter written by
Sidney Webb to his wife Beatrice in 1934. Both were
influential English social reformers, writers and
founders of the London School of Economics.

Ukrainian State Archives

"Every house had dead people and two people from the kolkhoz had to bury them. They went to every house with a horse and cart and in the cemetery they made a common grave. There was certainly not any religious ceremony. They were taken like timber and every day there was a large harvest of dead people. Sometimes even people who were not dead but dying were taken and put in the grave, they thought it would save time."

"Yesterday we went to the Ministry of Agriculture where we were received by some eight heads of departments under the Assistant Commissar . . . Incidentally the refreshments were absurdly lavish, dishes of cold meat, great caviar, sandwiches, masses of cakes and biscuits, several dishes of sweets of sorts, and a profusion of beautiful pears, grapes, peaches etc. They laughed at the idea of 6 million deaths from famine and minimised the extent of failure of crops. But they willingly undertook to read our draft chapter on Collective farms."

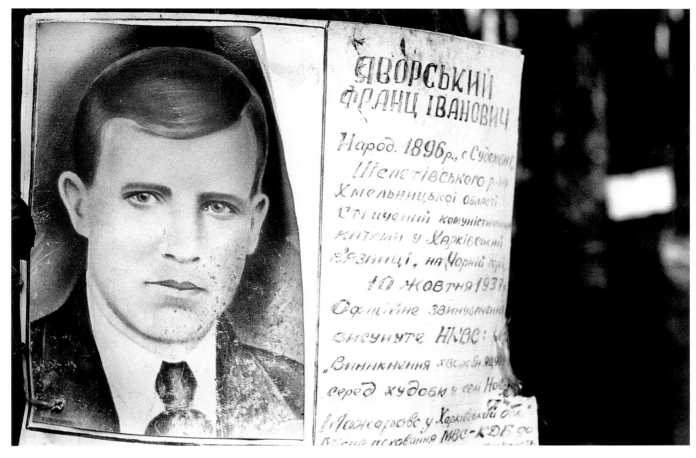

Memorial to Franz Ivanovich Yavorski, born in 1896 and who disappeared at the hands of the NKVD in 1937, pinned to a tree in Bikivnya forest in Kiev, 1991.

" I was arrested and accused of saying things about Stalin. They judged me for anti-Soviet agitation and gave me ten years of camps plus another five years when I had no citizen's rights: no right to live in big cities, no right to vote. We were sent to Siberia to a camp, working in the forest cutting wood for fifteen hours a day, from darkness to darkness. It was 45 degrees below zero. It was just forest and nothing else. People were just dying because there were no buildings: we had to build everything. I didn't see my mother for nineteen years."

"My brother was an engineer, his wife was a teacher: they took them. Then there were nationally conscious people: they took them. They took them but they left no trace of their whereabouts. The orders of Stalin were to destroy all the intelligentsia."

17

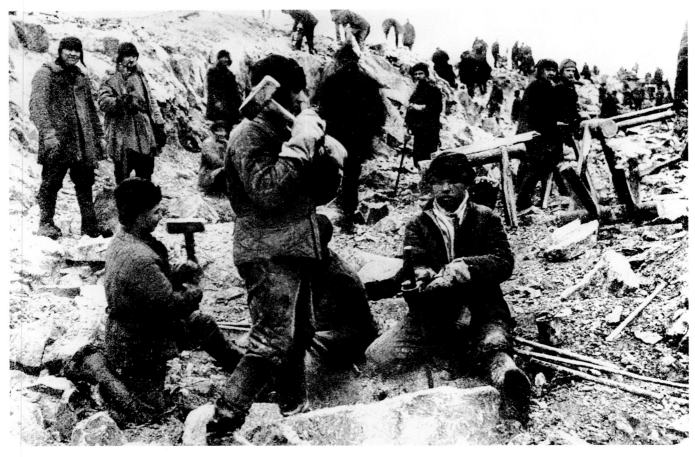

Belomor slave labour camp. 100,000 died in the construction of the canal at Belomor on the White Sea, near the Russian Arctic Circle.

David King Collection

"We lived not far from the sanatorium where my mother worked and two men came in plain clothes at six or seven o'clock in the evening on the 18th September 1937. We never saw my father again . . . I remember not understanding. We were not given a reason for the arrest so we thought maybe he would come back."

"My father was falsely accused of terrorist acts against the Soviet state and arrested by the NKVD. I now know he was shot the same night, within five hours of his arrest. My mother Alexandra was also arrested for being the wife of an enemy of the country and sentenced to eight years in the camps. In the week after my mother's arrest a man from the NKVD came and told me [aged nine] and my sister to leave the flat. So we were thrown onto the street."

Graves of Ukrainians who died in Lviv fighting against the Poles in 1919. Western Ukraine remained under Polish rule until the Second World War. Thereafter it became part of the Soviet Union, and the Communists flattened this cemetery as they considered it a symbol of Ukrainian nationalism. Following independence the graves are now being rebuilt.

"After the First World War, when Austria-Hungary began to disappear, Galicia was placed under the Polish government with the agreement that we Ukrainians had rights. But then the Polish applied pressure to undermine our language and promote Roman Catholicism. They sent Polish people on to Ukrainian land and the government helped them farm."

"Near my village my family had land, a beautiful place with a lake. In 1938 the government sent a Polish family to look after the lake. And one day there were some cows in our fields, and there was this Polish girl. I say 'What are you doing on my father's land?' And she says 'This is Polish land'. So I gave her a good hiding. But the next day the police came, and my father had to agree it was Polish land. They took over our land and gave it a different name."

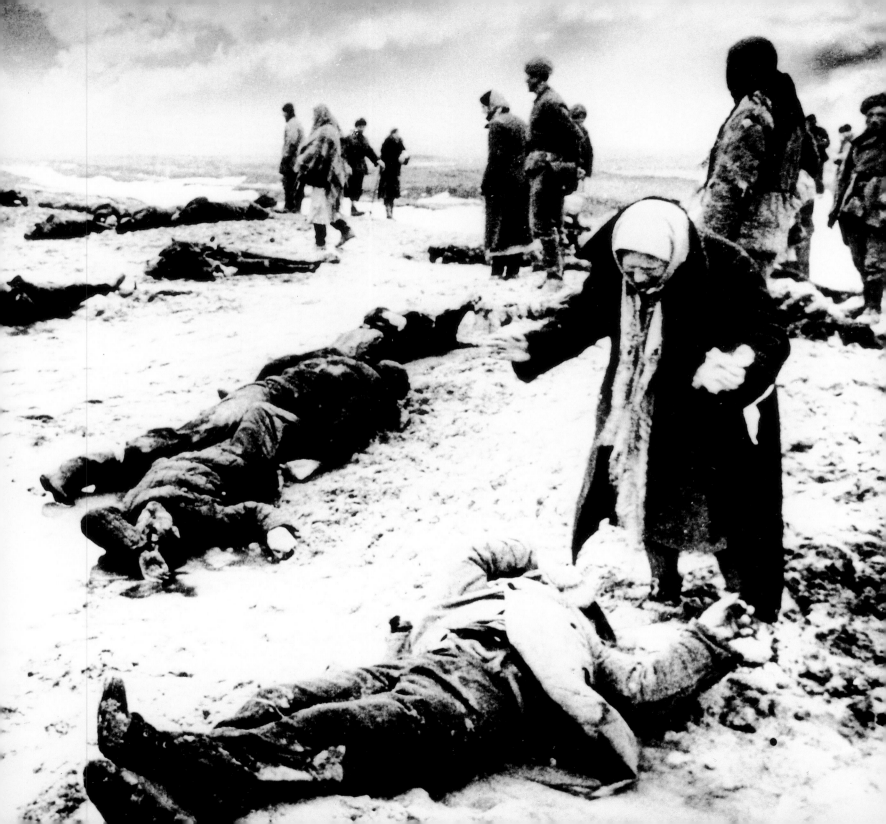

WAR: THE 1940s

The Second World War claimed the lives of 5.5 million Ukrainians including at least one million Ukrainian Jews. By contrast Britain's war dead totalled 300,000. Millions more were displaced during the War and scattered throughout the world.

In August 1939 a non-aggression pact between Germany and the USSR provided for the invasion and partition of Poland, Germany marching in from the west and the Soviet Army from the east. Galicia, or Western Ukraine, was for the first time in its history under Russian rule. Nikita Krushchev, First Secretary of the Ukrainian Communist Party, brought to the west the same collectivisation and repression that the east had endured, and a continuation of the policy of Sovietisation. 'Ethnic' Germans (or Volksdeutschen) were expelled by the Soviets from the territory they had occupied and moved west to the German-occupied part of Poland, and between 800,000 and 1.6 million people were deported eastwards. Although the latter included Jews and Ukrainians, the majority were Poles; almost the entire Galician middle class disappeared to farms and labour camps in Kazakhstan and Siberia.

The pact between Germany and the Soviets proved temporary and as early as December 1940 it was clear that Hitler was pursuing his own plans for the Ukraine. He was to comment that 'We'll supply the Ukrainians with scarves, glass beads and everything that colonial people like'. Such a view did not prevent the Nazis recruiting Ukrainian émigrés in Austria to units under German army command, code named 'Roland' and 'Nachtigall'. These units were used for sabotage and reconnaissance purposes when, on 22 June 1941, German troops broke the non-aggression treaty and invaded Western Ukraine. As the Germans rapidly advanced on Lviv, the retreating Soviet NKVD carried out horrific atrocities, hurriedly shooting thousands of prisoners including political dissidents. Given the harshness of Soviet rule it is hardly surprising that in

many parts of Ukraine the Germans were initially hailed as liberators – often with the traditional greeting of salt and bread.

While supporters of both the Melnyk and Bandera factions of the Organisation of Ukrainian Nationalists (OUN) in Ukraine agreed to German requests to promote demonstrations against Soviet forces, attempts by the Germans to bring about a reconciliation between the two leaders came to nothing. Doubts about the Nazis' aims led the Bandera wing of the OUN to proclaim Ukrainian independence on 30 June 1941 in Lviv – as soon as the city had been captured. However the OUN-B leadership was arrested and sent to Sachsenhausen concentration camp in Germany. Ukrainian hopes that the Germans would honour promises of re-establishing an independent Ukrainian state evaporated. In October 1941 the OUN-M attempted to establish a central Ukrainian government in Kiev. This too was soon disbanded by the Germans and a number of OUN-M leaders who were arrested were amongst those executed at Babi Yar in Kiev.

German occupation was particularly brutal towards the Jews. Special SS killing squads, the Einsatzgruppen, recruited Ukrainian police to round up and execute Jews in every village and town. 110,000 Jews in Lviv, one third of the total population of the city, were murdered or deported. Many were dragged from their homes and killed on the streets, often by mobs of local Ukrainians. In Odessa 19,000 Jews were burnt alive on the morning of 23 October 1941, and the following day a further 16,000 were herded into four warehouses and machine-gunned. But by far the worst atrocity occurred at Babi Yar, a large ravine on the northern edge of Kiev. In just two days, 29-30 September 1941, 33,771 Jews were murdered by a German Einsatzkommando unit assisted by Ukrainian militiamen. A further 70,000 bodies were added to the mass grave between 1941 and 1943. Babi Yar has become a symbol of the Jewish Holocaust in

e the NKVD
ore them the
is slaughtered
y people
n forced to
draw from
aine, such as
massacre of
ians at Kerch.

id King Collection

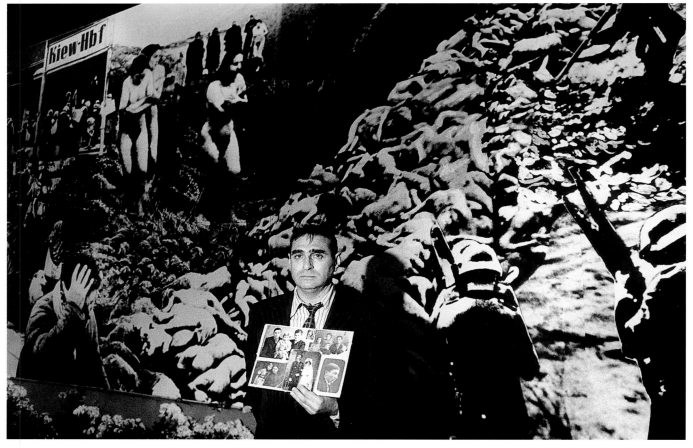

A man with pictures of his murdered family at the 50th anniversary commemoration of the mass execution of the city's Jewish population at the Babi Yar ravine. September 1991 marked the first time in 50 years that Kiev had officially mourned the dead.

"Germans when they came, they ordered to close down so many grammar schools. They didn't want Ukrainian intelligentsia, they wanted muscles for work. Because I was a talented student they sent me 120 kilometres from home, a much larger town … I saw hell there … One day when I was going to grammar school I had to step over dead Jewish bodies. Mothers holding babies killed by German drunkards who had executed Jews during the night. Those that they caught were ordered into columns and taken to the railway station … If you could see the mothers with the babies killed, that would haunt you until today."

"Ukrainian policemen formed a corridor and drove the panic-stricken people towards the huge glade, forced the people to undress, and then to go in the columns in twos towards the mouth of the ravine … on the opposite side there were the Germans' machine guns. Then the next hundred were brought, and everything repeated again. The policemen took the children by the legs and threw them alive down into the Yar. The Germans undermined the wall of the ravine and buried the people under thick layers of earth. But the earth was moving long after, because wounded and still alive Jews were still moving. One girl was crying 'Mammy, why do they pour the sand into my eyes?'"

Ukraine, and inspired Dmitri Shostakovich to compose his Symphony No. 13, Anatoly Kuznetsov to write *Babi Yar*, one of the most important literary works to come out of the War, and Yevgeni Yevtushenko to write his moving poem of the same name.

There is not only evidence that Ukrainian police assisted in these executions, but later reports, endorsed in recent years by the House of Commons All-Party War Crimes Group, have disclosed the part played by those Polish and Soviet Ukrainians who served as concentration camp guards at Belzec, Treblinka and Sobibor. At the same time there were instances of Jews being helped by non-Jewish Ukrainians to survive the Holocaust. For example, Simon Wiesenthal in his autobiography writes of being spared and later saved by a Ukrainian guard.

In the early winter of 1941 men and women were being sent by the Nazis from occupied Ukraine and Russia to the Reich as enforced workers. By November 1942 local resistance to this recruitment was met with reprisals that included the burning down of farmsteads and entire villages. A total of 1.3 million civilians were transported to Germany from April to December 1942 alone. Although the average age of these workers was around twenty, many were much younger. The 'Ostarbeiters', as the Nazis called them, worked in both farms and factories. The factories are recalled with particular horror: operatives were often poorly fed, badly treated, and made to work long hours.

By the winter of 1942 the nationalist underground Ukrainian Insurgent Army (UPA) was formed, initially from young men fleeing imprisonment, deportation, or execution, but involving both Bandera and Melnyk supporters. Yet while early in 1943 Ukrainians who were serving in the German auxiliary police deserted to join UPA, there were at the same time Ukrainians, including prisoners of war and even members of UPA, who were joining the German forces.

The defeat of the German army at Stalingrad in December 1942 was the turning point of the war, and in 1943 it was the turn of the Red Army to advance through Ukraine. Some Ukrainians chose to join the special Galician (Galizien No. 1) or *Halychyna* 14th Division of the Waffen-SS to fight against them. Between April and June 1943 as many as 30,000 men were recruited to this volunteer division as the Germans tried to stem the Soviet forces' advance, particularly after the Battle of Kursk had led to the collapse of the German front. After training in Poland and Germany the division was sent into battle and was heavily defeated at Brody in July 1944. The remnants of the division were regrouped, renamed the 1st Ukrainian Division, and brought up to strength before being sent to Slovakia and then Croatia. At the end of the War the division was withdrawn to Austria and, after renaming itself the Ukrainian Liberation Army, surrendered to the British in May 1945. UPA continued a losing campaign of sabotage and guerilla warfare against the re-occupying Red Army until the early 1950s, mainly from secret bases in the Carpathian mountains.

The War was a brutal conflict that set Ukrainian against Ukrainian in a country that was divided and fought over by occupying powers. As well as fighting for UPA and in German units, Ukrainians fought in the Soviet forces, in both the Red Army and in partisan groups, and in a variety of other armies, including Romanian, Hungarian, Polish, and Serbian. Large numbers also served with the American and Canadian armed forces. Some even could be found in the French resistance. Ukraine at the end of the War was one country, although under Soviet control, and the calculated inhumanity of the conflict had ensured that it was more homogeneous in its ethnic composition than at any time in its history.

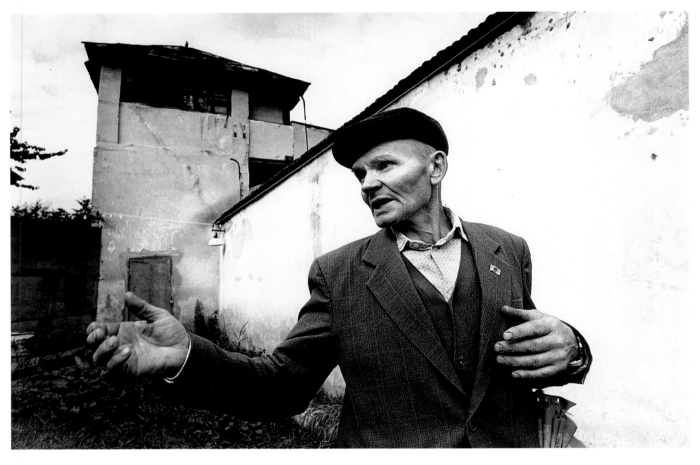

Petro Beimuk recalls witnessing torture and mass executions at Stryi prison.

"Already before the outbreak of war there were rumours that people were being killed at Stryi prison. So when the Germans arrived in our village there was a notice given that in Stryi prison there were a lot of murdered people. I went with my father. When you arrived you could hardly breathe because of this almost poisonous air. There were clothes strewn about covered with blood. On the walls were blood stains. As people were recognised there was a lot of crying... Just as I arrived a crater had been opened full of bodies. I remember this smell and barbarity. It was all done in secret. I couldn't at that time understand this moral and psychological terror."

Victims of Nazi
atrocities in
the Ukraine.

David King Collection

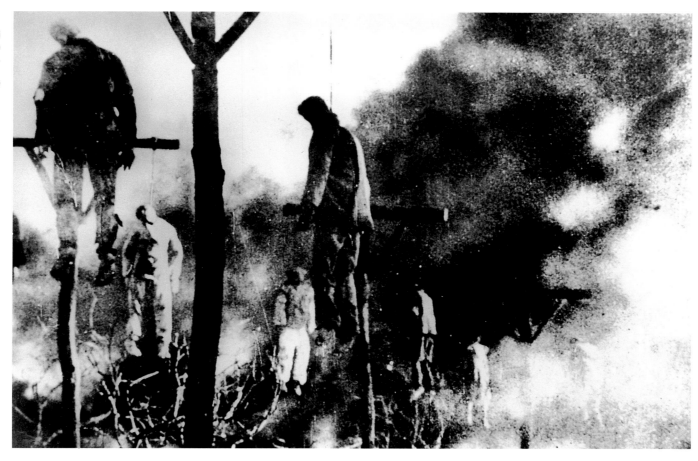

"When the Germans came we welcomed them with milk, bread, butter and eggs. The village was like a paradise with Germans offering cigarettes, chocolates, all the goods that come from the West. The people could see with their own eyes that this was a different army altogether. So they put up Ukrainian flags."

"My father was sent to bury bodies, and he took a passport from one of them. It was an Armenian passport. When they were shooting the Jews I had a good friend who was a Jew, and the Germans were searching for him. He came to me. We were sitting at my place, and the Ukrainian police, the collaborators, came and looked for him but didn't find him. He was hiding. My father gave him the passport and with the help of that he got through to the Soviet troops."

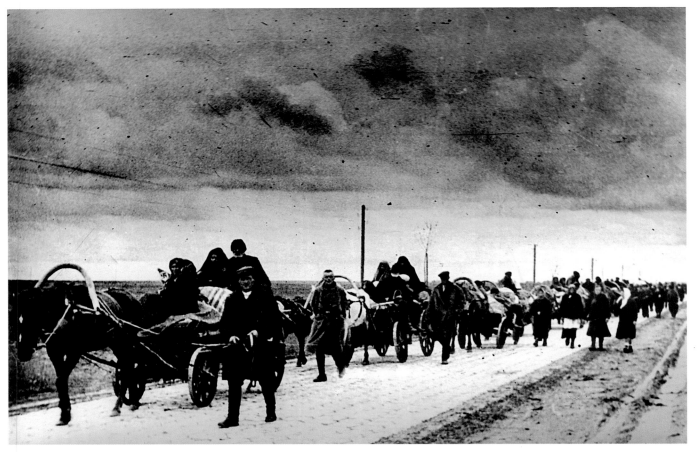

Ukrainians being taken to Germany to work as slave labourers in 1941. Their average age was twenty and half of them were women. By 1944 there would be 5.7 million registered foreign workers in Germany, 87% of them from the East.

Ukrainian State Archives

"We thought the Soviets would liberate us from the rule of Poland and we thought the same about the Germans. At first we were very excited at the coming of the German Army. At that time the independence of Ukraine was proclaimed, but when they started arresting, we understood it was another yoke."

"The Germans were careful to prevent the Ukrainians becoming organised. They began massive arrests and sent people to forced labour camps in Germany, weakening any resistance at home and supplying Germany with slave labour. One day men in black uniforms came to our home and informed my father that since I was 15 years old, I must go to work in Germany. And so it was my turn to say goodbye to my parents, to my Ukraine."

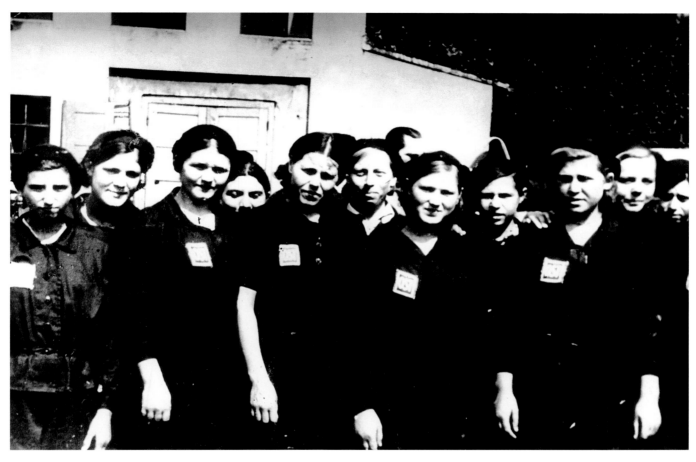

Ukrainian women working as 'Ostarbeiters' in Germany in 1942. Ostarbeiter, or 'eastern worker', was the official German term for Soviet civilian workers.

Ukrainian State Archives

"I was in bed when they came and 'invited' me to Germany. They gathered us together. The youngest was about fourteen – she was still in school. They put us in an army lorry and then take us to Cracow, Poland, and then to Germany. They bring us to barracks near the Siemens factory. There were Poles and Russians as well. It was the 19th December, 1942. It was hard work on heavy machines which men had been using before we came. I was working there nine months on nights. I think I cannot take it any more, but it not right to take your own life. I've seen Russian girl drink acid used for metal working. She was taken to hospital. She was nice girl – good looking. How they saved her I don't know."

"All the people stood on the main road when the German Army came in on motorbikes, and even now I am terrified of motorbikes. They always bring me the memory."

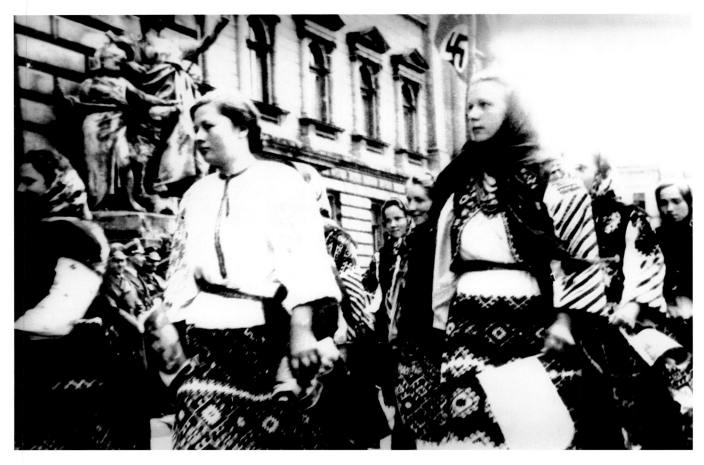

Parade held in Lviv in 1943 to celebrate the formation of the 14th Waffen-SS Galician Division. Formed from Ukrainian volunteers they fought initially against the Red Army and subsequently against partisans in Slovakia and Croatia.

Ukrainian State Archives

"There were German soldiers who made friends with the people when they came. We expected Germans to liberate us from Stalin's terrorism . . . And even church bells were ringing for joy. But that joy didn't last very long, because one devil gone and a second had come. The party members, the bastards, came later to implement Hitler's policy that we are nobody, that they had come to colonise the Ukraine. And like the Russians they started to impose compulsory quotas of grain, meat, eggs, milk. And then they started taking youngsters to Germany to slave labour camps, to work in the factories."

Members of the
Galician Division
photographed in a
makeshift studio in
Yugoslavia, 1944.
In 1945 the Division
surrendered to the
British and were sent
to Prisoner of War
camps in Rimini, Italy.

BHRU archive

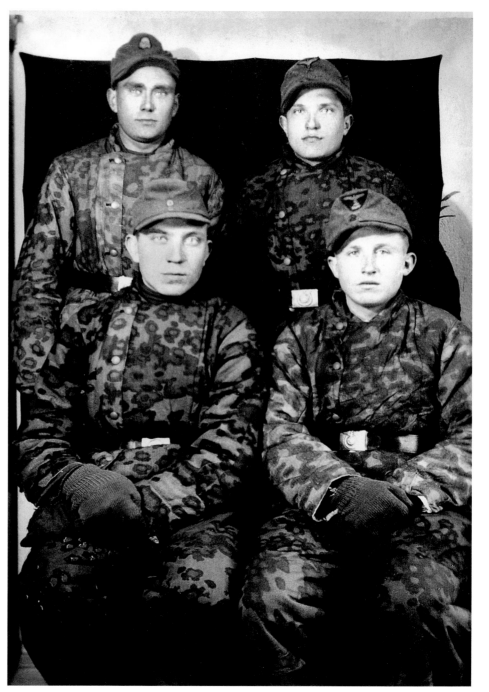

"Options available were stark and simple: be sent to Germany and the factories, join the partisans, or join the German army. So I joined the army."

"When I first joined the German army I was seventeen years old and an idealist who wanted to see his country free. I was at the Battle of Brody. We were encircled and my battalion was destroyed. What could we do? Well one thing was not to surrender to the Russians, because they would shoot us. We ended up fighting with bayonets, four hours of hand-to-hand fighting at night. The Russians fired rockets with phosphorous – wagons, horses, soldiers burnt, it was like hell, an inferno. Terrible. After four hours I had lost my strength, but we had broken through the Russian line. And one German soldier came to me with some drink. And down in the valley I saw the houses and people all burning. But then it was a nice morning, and it was like a resurrection from hell."

"We know we want to fight against the Communists – the Russians. Well I say Russian, but half the Russian army were Ukrainian people. I remember in Austria one lad captured his father when we raided a farm. One day that father was a Russian soldier – the next morning he was with us. There was a lot of it like that."

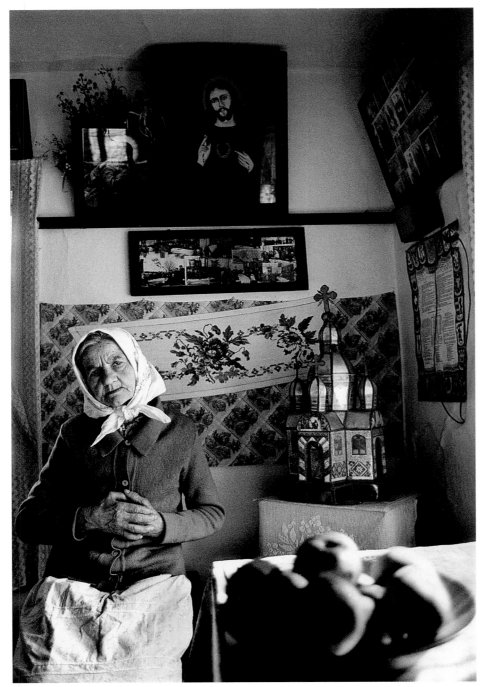

Anna Kravchyshyn in her home in Slavsko, near Lviv. She was a courier for UPA as it continued its guerilla war on the reoccupation of Ukraine by the Soviet Army.

"In December 1942 the Germans wanted to send all the boys in our school to Germany. So we went through a medical examination and were issued with uniforms. I was seventeen – just the right age. Then we find out that they want to take us to Hamburg and train us as firemen. Some of the lads went and some of us went to the forest and we start the war. We were seventeen, eighteen, nineteen, twenty – our leader was the oldest chap. In small groups – up to twenty-five or thirty men – we start ambushing the Germans. The rural areas were controlled by the partisans, the towns by the Germans. Then we had an instruction from the Organisation in December 1943, telling us to prepare ourselves for when the Soviets come."

"The NKVD killed a lot of members of my family: my brother, my adopted son, my uncle. I was in hiding until 1947. I helped the men in the forest, washed their clothes, and I used to stand guard also. They were singing songs: they sung about freedom but they didn't have any freedom."

A UPA safe house in the Carpathian Mountains which provided an ideal landscape for guerilla warfare against the Germans and the Russians. Living in the forests by day they would visit their supporters at night to collect supplies and exchange information. They survived until the early 1950s, carrying out raids on Soviet installations and personnel.

"I became a regular member of UPA in 1942. I wouldn't have been Ukrainian if I hadn't fought. As far as these Gestapo and NKVD people were concerned they had no mercy on anyone. I didn't feel anything about killing them. I knew what terrible things they had done to my own people. Even today I would kill them."

"I was arrested because of my brother and deported to Siberia. My brother was in UPA – I don't know exactly how long because he didn't tell me. He was a commander . . . During the war members of UPA spent the night at my house, I fed them and helped them because of my brother."

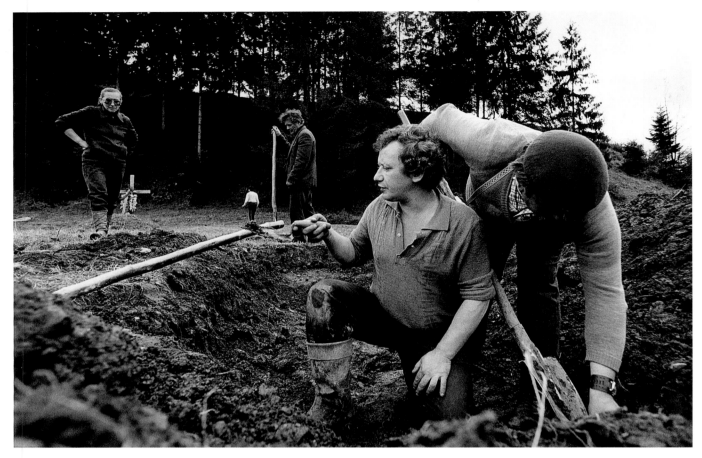

Site of mass grave in Slavsko, until 1960 the district's NKVD/KGB headquarters. Some bodies are those of UPA partisans, most are ordinary people killed by the so-called 'Red Broom'.

"I went to school with my brother and I remember that bodies of people were brought to the NKVD headquarters which is now the hotel. They put the bodies so that children could see them. Every day there were new bodies: they were stark naked. I saw bullet holes everywhere. I recognised very many of the bodies: there are many of my relatives here. My brother-in-law commanded one of the UPA platoons."

The exhumation is carried out by 'Memorial', an organisation dedicated to uncovering past atrocities of the Soviet system, and whose members include medical and legal experts.

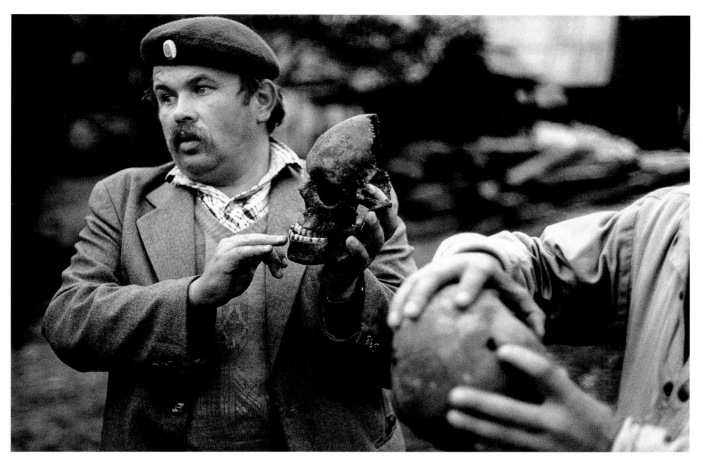

"The aim of the excavations is to gather information to begin court cases against the perpetrators. When we started digging in 1991 no-one would come up because everybody was afraid. After a month some people came up to testify. We identified one man from his buttons, another by his shoes."

"The main cause of death is violent murder, most of them being shot in the head."

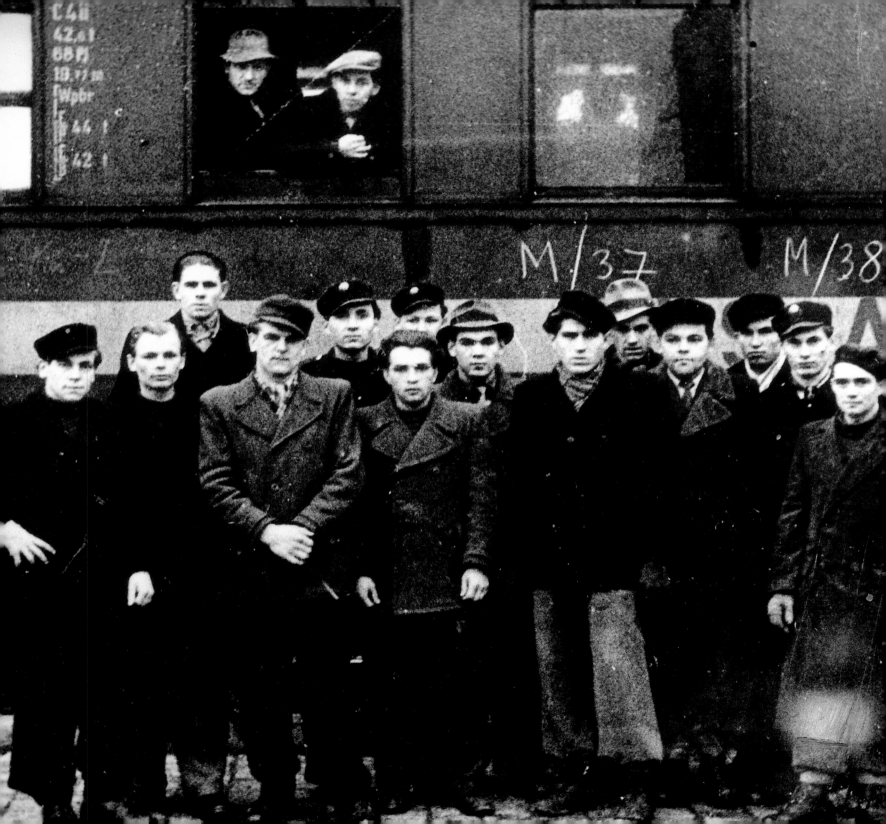

LEAVING: THE UKRAINIAN DIASPORA

Ukraine emerged from the Second World War united but under Soviet rule. Many of the Ukrainians who had been 'Ostarbeiters' in Germany fled to the West to avoid Soviet reprisals, and ended up as Displaced Persons (DPs) in United Nations refugee relief camps. Between 1947 and 1950, after registration and screening, they were awarded European Volunteer Worker (EVW) status and given the choice of settling in Canada or Britain. Over 21,000 chose Britain (mainly because it was closer to Ukraine), and were allocated to three industries suffering from labour shortages: coalmining, agriculture and textiles. The EVW 'Westward Ho' scheme recruited healthy adults, while older people, youth and children were excluded. This meant that dependents were left behind in the camps, and families who had struggled to remain together were often separated.

In May 1945 8,400 former members of the Ukrainian Waffen-SS Galician Division of the German Army surrendered to the Allies and were then interned near Rimini in Italy. In March 1947 pressure from the Soviet Union for their repatriation (and probable imprisonment or execution as collaborators) spurred their transfer to Britain. Controversially, in 1948, most were admitted as civilians as part of the EVW scheme.

By 1951 there were 34,000 Ukrainians in Britain, the vast majority from the rural parts of Western Ukraine. Most of the settlers who arrived in Britain after the Second World War were initially accommodated in camps but, after being placed in jobs, employers either offered places in hostels or rooms were found with local landladies. The quality of such accommodation was varied and hostels and landladies are recalled with mixed feelings. Amongst the settlers men outnumbered women; there were almost four men for every one woman amongst the Ukrainians who took part in the 'Westward Ho' scheme. As well as marrying Ukrainians, the men also found wives amongst migrant workers of other nationalities, notably Italians (although some men remained unmarried). By the

late 1950s there were seventy communities dotted around Britain, the largest in Bradford, Nottingham, Manchester and Coventry.

Ukrainian communities in exile established themselves quickly. Clubs were established by both the Association of Ukrainians in Britain and the splinter Federation of Ukrainians. Ukrainian language schools were set up to educate the new generation, and Ukrainian Catholic and Orthodox churches were established. Choirs, dance and scout troupes followed. The community became politically active, protesting against Russification and repression in Ukraine, most notably by marching against Soviet leader Khrushchev's visit to Britain in April 1956. They were also active in clandestine operations, including smuggling banned Ukrainian language publications and bibles into Ukraine. Miniature versions of religious and history books were even produced (some as small as two inches by one inch) to avoid being seized by the authorities. Political protest also included joining other 'occupied' nations of the Soviet Union to form the Captive Nations Committee.

In the 1950s an unknown number of Ukrainians left Britain for Canada, the United States and Australia. North America proved attractive especially for those with friends or family who were already there. And then there were other reasons that drew Ukrainians towards Canada in particular. Ukrainians had contributed much to the development of Canada from the nineteenth century onwards, and they formed a substantial part of the population (they were the fifth largest ethnic group). Between 1891 and 1914 170,000 settlers had migrated from Ukraine; 65,000 entered in the 1920s; and a third successive wave arrived between 1948 and 1960. While the third wave to arrive benefited from an existing community, there was a feeling amongst earlier migrants that those who arrived after the War were somehow different. Part of that difference was that while earlier arrivals were keen to establish their part in the history of

en the Allies
ran Germany
he end of the
they found it
sh with
eigners who
e members
he German
tary, workers
conscripted
urers, or
gees. Here
ainians board a
n in Stuttgart
ravel west at
end of the war.

RU archive

the Canadian nation, the later migrants believed that they should be more concerned with the future of Ukraine.

Canada was nevertheless perceived as capable of providing opportunities for migrants who were from both rural and urban backgrounds. Ukrainians were also politically influential in a society that seemed to be willing to accept, and indeed celebrate, ethnic differences. In recent years Ukrainians have continued to play an important role in Canadian politics and in 1987 assisted in ensuring the recognition of multiculturalism in the country's constitution. In 1991 the Canadian Census reported that over a million people were of Ukrainian descent, mostly living in Ontario and Alberta.

Like Canada, the United States is home to several generations of Ukrainians and the migrants who arrived after the War found a well established and a well-organised community. As well as new political organisations the post-1945 arrivals also assisted in establishing credit unions and supported the development of educational provision including, in 1970, the endowment of three chairs of Ukrainian studies at Harvard University. By 1980 there were 730,000 people of Ukrainian descent in the United States.

Australia, like Britain, traces the origin of the Ukrainian community back to the DPs who had arrived by 1951 and settled into the cities of Adelaide, Melbourne and Sydney. Here there is a much more equal mix of East and West Ukrainians than is found in Britain. Politically Ukrainians in Australia, like Canada, have managed to maintain a degree of unity missing from Britain and the United States where the nationalist organisations tend to be in competition.

By the early 1990s there were over 2.5 million people who described themselves as Ukrainian and were living outside of the former Soviet Union. As well as in Russia, Britain and North America, there are large communities in Poland, former Czechoslovakia, and Romania, and smaller communities in Bosnia, Germany, and in Latin America (most notably in Brazil and Argentina). In recent years émigrés and migrants have begun to think of

themselves as the Ukrainian diaspora. Indications suggest that the diaspora is more and more concerned with the future of Ukraine, although there continue to be difficulties of dealing with the past including coming to terms with change in a homeland that was inaccessible for so long. There are also tensions between the communities of the diaspora and those who have more recently left the homeland. Amongst the communities in Britain, for example, stories circulate of opportunistic Ukrainian relatives making unacceptable financial demands, and even visitors from Ukraine who are involved in racketeering (including connections to organised crime).

In Britain in the 1990s there are striking differences in the life stories of the older men and women who arrived in Britain in the 1940s. While men talk about their place in the Ukrainian community, the women's recollections are more likely to centre on work and family. The women's working lives tended to be similar to those of many other women in Britain; that is a return to a narrow range of jobs five or so years after the birth of their children. However, Ukrainians were much more likely to own their own homes, with ownership often achieved by the borrowing, lending and temporary pooling of money within the communities. Ukrainian parents were also much more likely to take an interest in their children's education – as the children themselves remember. Children and grandchildren are in a range of occupations, including teaching and medicine, that is much more varied than the jobs experienced by those who arrived immediately after the War. There have been improvements in education, employment opportunities, and living standards amongst Ukrainians, and this is a source of pride amongst the older generation. Such changes have also meant dispersal from the communities, and Ukrainians are now much less likely to be concentrated in the inner city areas where they first settled. Despite all the problems and changes the transnational Ukrainian diaspora, including the communities in Britain, will play a part in the future development of Ukraine.

Displaced Persons camp in Germany just after the war.

BHRU archive

"I went to a camp on the American side. There were 37,000 people in the camp. We go to register, and I say 'I am Ukrainian', and this stupid woman says 'Where is Ukraine?' The man next to her says 'Write down what you have been told'."

"I knew why we hadn't joined in rejoicing. For most the war had ended, and I was glad for them. But for us, Ukrainians could not go home, because when most nations go home, when most nations tasted freedom Ukraine only changed hands. The Germans were gone and the Russians had taken over. Therefore we were Displaced Persons with nowhere to go."

"In the D.P. camp we started Ukrainian life. There was a school organised, a dramatic society and a choir. There was a church, a very full life really."

MS2S/M/3L-20

PG 012133 ✿

Office of the Military Governor

U. S. Zone of Germany

CERTIFICATE OF IDENTITY IN LIEU OF PASSPORT

1. DEMTSCHUK Jaroslaw
(name in full)

born at Torki Sokal Pol Ukr
(town) (district) (country)

on 8 of June July 1923 M Pol. Ukr.
(day) (month) (year) (sex) (citizenship)

(given & maiden name of wife, if applicable)

intends to emigrate to

GREAT BRITAIN
(country of immigration)

2. He (she) will be accompanied by none

(List here all family members, with name,
birthplace and date, and citizenship
of each)

3. His (her) occupation is Factory worker

4. DESCRIPTION

Height 5 ft 4 inches
Hair d'blond Eyes grey

Distinguishing marks or features: none

PRESTO

(signature of applicant)

5. He (she) solemnly declares that he (she) has never committed nor has he (she) been convicted of

any crime except as follows:

6. He (she) is unable to produce birth certificates, marriage license, divorce papers and / or police

record for the following reasons: lost during the war

7. I hereby certify that the description of the person(s) whose photograph(s) is affixed hereto is cor-

rect and that he (she, they) declare(s) that the facts stated above are true.

(signature of applicant)

Signed 13 January 1948
(day) (month) (year)

at Stuttgart
(location)

Paul J. Mc Cormack
(signature of certifying officer)

DP BRANCH CAD. EUCOM
(position)

EMPLOYMENT OF UKRAINIAN MEN IN GREAT BRITAIN

Terms and Conditions

ЗАТРУДНЕННЯ УКРАЇНЦІВ У ВЕЛИКІЙ БРИТАНІЇ

Умови і Обставини

Identification papers issued
to a Displaced Person.

BHRU archive

Papers issued to Prisoners
of War outlining the
work that they could
do in Great Britain.

BHRU archive

"One day two British arrived, called a meeting and through the interpreter told us that if anyone wanted to come to Britain then they would be welcome. There was plenty of work and we would all get a job according to our professions. I jumped at the chance as I didn't want to be too far from my own country."

"I came to England and started life in civvies with one small suitcase and a torn shirt!"

"We discovered that England did not match the rosy picture that had been described to us by the British authorities in Germany. We also found out we were allowed to pursue only certain jobs: farming, textiles, coal-mining, quarrywork and portering. Job restrictions were to last 10 years."

German, Latvian and Ukrainian Prisoners of War working as kitchen staff. Reigate pow camp, Surrey, 1947. Many Ukrainians were also placed in Displaced Persons camps all over Britain.

BHRU archive

"In Full Sutton transit camp [near York] we had a communal life. Sitting reading books, and studying English, girls were laughing. We formed a choir, a dancing group, there was a bit of a social life for the months we were there."

"I didn't go much out, because we didn't earn a lot. When we get a little money, you want to save and buy clothes. We didn't have clothes, and we got coupons and buy nice clothes. We wanted to look same like English people. We don't want to be different."

"I remember in '48 we were allowed to visit local towns. Some Englishmen would not let us board their buses, 'Sorry, no bloody foreigners.' We had to wear white square patches on our backs and trouser legs, so we dyed them with boot polish before going out, so as not to be recognised as those 'bloody foreigners'. But everyone knew. We looked foreign. We were foreign."

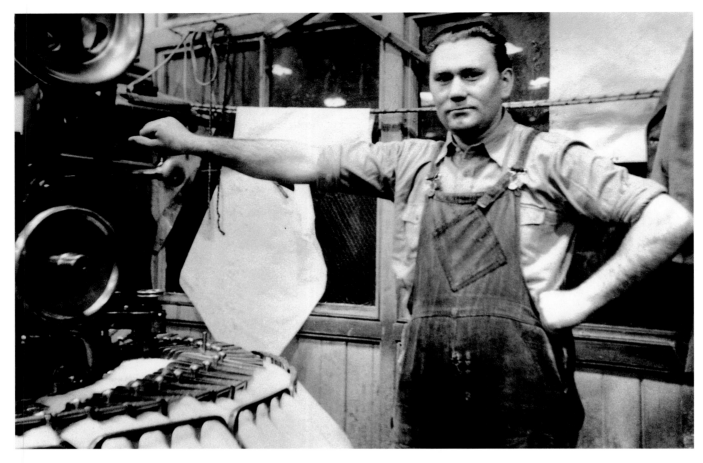

The textile mills of northern Britain faced a severe shortage of labour after the war, and were a common destination for European Volunteer Workers such as this Ukrainian man.

BHRU archive

"When we first arrived in Bradford it was a very, very hot day. I can remember the stench of unwashed wool was so strong it was overpowering. And I said to the others 'I don't know how people can live in a place with a stench like that lingering in the town'."

"I came to England in 1947. The gaffers came to collect us from the railway station. And all the landladies were waiting for us to take us to lodgings. Some of us started in spinning, warping or winding. I started work 20th October 1947 as a weaver in Shipley. From the beginning I liked weaving."

March in Halifax, one of many held in Britain protesting about the Soviet occupation of Ukraine, 1950s.

BHRU archive

"The very act of defining yourself as Ukrainian was political, challenging the established authority, Polish, Soviet, whatever it was."

Protest march, Trafalgar Square, London, 1950s

BHRU archive

"I was fourteen. The first demonstration that we were very much involved with was in 1968. Up until that time, there might be a few lines in the press about Ukrainians celebrating Christmas, but following that demonstration there was a boom in the kind of coverage we were getting. We felt we were heightening people's awareness of what was happening in Ukraine. It coincided with the big movement in Ukraine with the people of the '60s, the writers, the poets, the artists, talking about 'This is our own country'. Many were being arrested. We used to walk round with their books in our hands all day long, reading and talking to each other about what was happening."

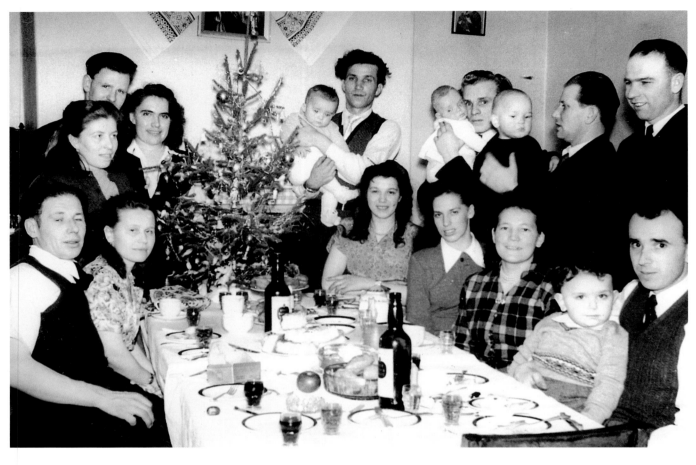

Celebrating Christmas on the seventh of January in a Ukrainian household, 1950s.

BHRU archive

"*Godparents were subsidiary family, because we didn't have any aunties and uncles living in this country. So they became extended family and those types of relationships became very important. I've got cousins through Godparents. Godparents were people you could trust.*"

"*My dad knew my Godfather through lodging. They bought a house together, and lived together before going their separate ways. My Godmother, she emigrated to Canada. The connection was the DP camp in Germany. A lot of older people have kept up those links when trustworthy relationships were formed.*"

Young Ukrainians
outside the first
Ukrainian church
established in
Bradford on
Farfield Road in
Manningham, 1950s.

BHRU archive

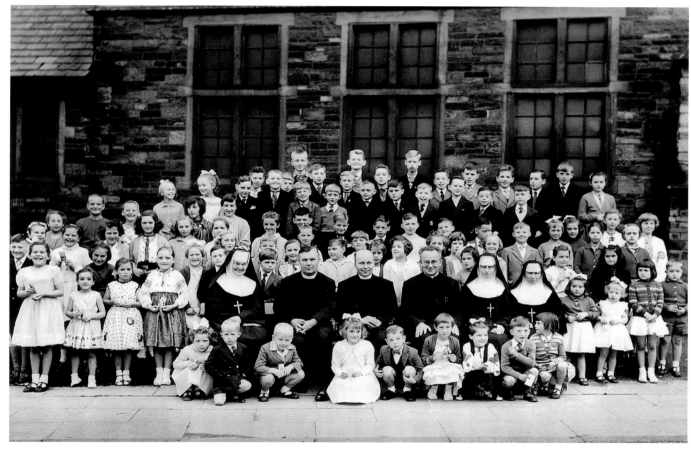

"I grew up in a Ukrainian "ghetto" in London, Whitechapel, off Brick Lane. Those two streets were just full of Ukrainians in tenements. The lady above us was Ukrainian, the man below us, our neighbours on either side. On Sundays the mothers took turns to feed everyone, so one Sunday would be spent at somebody's house and that's how we could keep the language going. We didn't know any English until we went to school."

"I started young, I taught Ukrainian Saturday School from fifteen. In English school I was still taking my O-levels, treated as a pupil, and yet in the Ukrainian community I was a teacher. So at that age I was pretty powerful really, and it made you want to stay and have that influence. But for others, that's probably where the community lost a lot of youth, because it was just one-track. Our parents knew that Ukraine was being Russified, so they were trying to do the opposite with us, and make us the guardians of the language and traditions, and anyone who didn't fit in – well, they just didn't fit in."

"This was a chance to don our national costumes and recreate our customs. Community spirit, that sense of belonging, pulled us through."

In 1963 the Ukrainian Youth Association bought a disused army base in Weston-on-Trent, near Derby. Young people travel from all over the country for the annual summer camp held here, such as this one in 1971.

BHRU Archive

Two sisters pose for their school photograph during the 1970s.

BHRU archive

"I was the only Ukrainian at the school until my sister came along, because it was an English school — hardly any foreigners. We were foreigners, different, alien. I wouldn't say I was bullied, but they made sure you knew you were different. My first day at school I didn't know a word of English. I vowed that if I had children of my own they would know Ukrainian, but I'd make sure they'd know English as well."

"We were classed as weird and unusual at school. We dressed differently. We always had pigtails and we stood out. At that time it [the fashion] was like short bobs and flicks and pony tails. My dad and mum always wanted us to have long hair and my dad insisted we have it tied up in plaits. I don't mind being different, but my sister, she's still struggling to find her I.D. They called us onions and garlic at school. My sister wanted to fit in, I wasn't bothered."

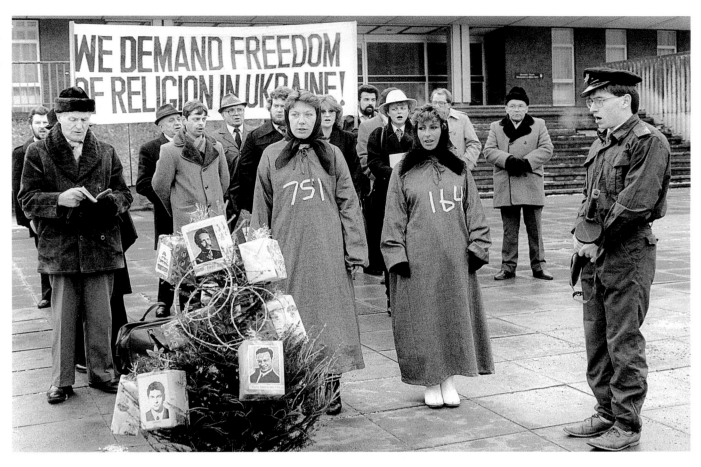

A Christmas vigil for those jailed and disappeared in Ukraine due to their faith, Bradford, 1986.

"We took each and every opportunity that we could to make our presence felt, so that people would take notice and say, 'Well, what is going on in the Soviet Union?'. There were horrendous stories coming out of there, about the psychiatric wards where they would send dissidents. But people were saying you're crazy, it's a figment of your imagination, it's just propaganda. But then, fortunately, Solzhenitsyn's writings were coming out, a perspective from somebody else. The Gulag Archipelego, that was beginning to lend credence to all the things we had been saying. Our parents had been viewed as fanatics who couldn't actually let go of the past. Then all of a sudden in the '60s and the '70s people knew what they were talking about. This was our opportunity to stand up and support this country which we had never seen but had been taught to love so dearly."

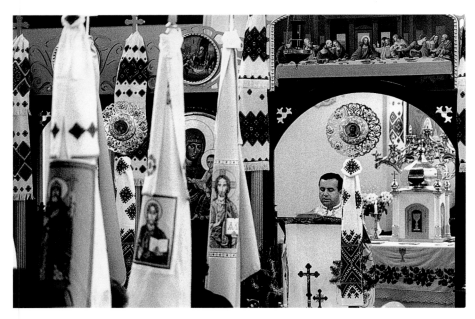

Christmas day service on the 7th January, 1997, at St. Mary's, the Ukrainian Catholic Church in Cheetham Hill. When Ukrainians first settled in Manchester this area was at the heart of a large but closely-knit community.

"We were amongst the first families of Ukrainians that came to Bradford. We met some more Ukrainians and they told us about St. Patrick's Church and every Sunday we went there more and more Ukrainians came. The priest took notice of the big groups of Ukrainians gathered after church and offered us the use of the church hall. We started our Ukrainian social life. First of all we organised an English language class and I was teaching English. Then we organised a choir, a library, a dramatic society, and formed a local Association of Ukrainians in Great Britain."

Most of the Ukrainians in Britain originate from Western Ukraine and are members of the Ukrainian Catholic Church. However there are significant numbers of members of the Orthodox faith many of whom are from Eastern Ukraine. The Wesleyan Chapel in Eccleshill, Bradford, purchased in 1963, was one of the many empty British churches converted by the community into a Ukrainian Orthodox Church.

"The church is always trying to help people. I [the priest] go to the solicitor with them, Welfare Office, Housing Department. Everything they need they ask me. If I cannot do it, I give advice who can do it."

"We didn't have any capital, but every family said 'Right, I give so much.' So we pay £3,500 cash, and we only have ten shillings in our treasury. But the people start doing voluntary every weekend, joiner and plasterer and everything."

Torch-lit procession to Manchester Town Hall to mark the 10th anniversary of the Chernobyl disaster, 1996.

"The Women's Association sent out letters to the regions proposing that we give help to the families in Chernobyl. We sent three lorries from London. There was a bus from Bradford that went down to see the three wagons off to Ukraine and that trip was very emotional. But it bound the Women's Association together, because it showed the caring work of the women's branch. In olden times all that the fellas wanted was for women to be in the kitchen. But the younger generation want a higher profile for the women – to show that they can be involved in other things apart from cooking. That's why our President travels to the Women's Associations in Canada, the States, and in Ukraine, and they come across here. A lot has happened over the last few years. Most of the older men support us, but there are a few who don't like to give over the reins easily. Although we are older than when they started up they still see us as the young ones."

Jaroslaw Rutkowskyj raises the Ukrainian flag outside the Association of Ukrainians in Bradford to acknowledge the declaration of independence, August, 1991.

"Since independence people, especially the older ones, look about twenty years younger. They don't have serious faces, there's been a big weight lifted off everybody's shoulders."

"We saw ourselves as an exiled community with a responsibility to keep alive Ukrainian culture, its identity, institutions that were destroyed over there. However, that job has in a sense been done, Ukraine is looking after itself, but we do have a supportive role at least."

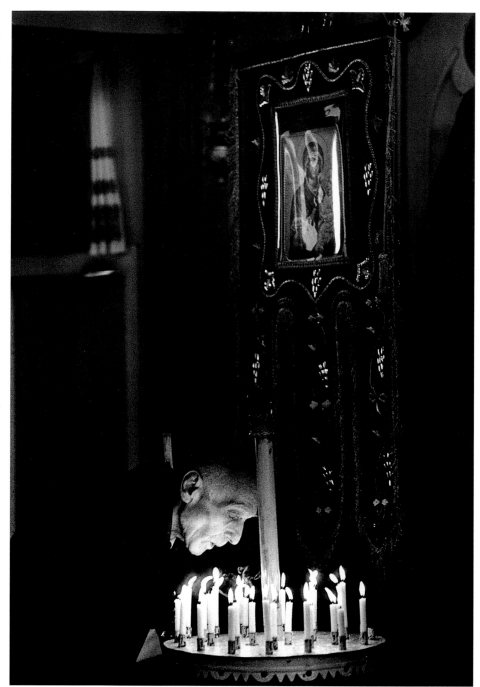

Extinguishing candles
at the end of a
service at the
Orthodox Church
in Bradford, 1990.

"The dream was always for a free and independent Ukraine, and in their heart of hearts they would love to go back and possibly settle back home. Memories of childhood and family. But the reality of Ukraine today is what it is, it's another thing when you're old. But people live by their dreams, it's what carries them forward."

"Another Christmas will be coming and in the Ukraine there is an old tradition that on Christmas Eve at the Holy Supper a vacant seat is left at the table and a candle is lit and placed in the window. It is to light the way for a missing member of the family to come safely home. Then perhaps there will also be a vacant place and a lit candle for me, if someone still remembers."

Second generation Ukrainians lead off the dancing at their wedding reception, 1987.

"I'm Ukrainian because it's your roots but at the same time I also recognise that I'm British. I feel that I'm enriched by Ukrainian heritage and also by English heritage, getting the best of both worlds."

"I don't think we will stop existing. We have got a big community, and young people who know Ukrainian language and culture. I think they will continue work which the older generation started. In America and Canada, they've been there over a hundred years and still have their own churches, schools and way of life."

Art class (above) and Ukrainian language class (below) at the Saturday school held at the Ukrainian Club in Cheetham Hill, Manchester, 1997.

Easter celebrations at the Ukrainian centre in Cheetham Hill include classes in pysanky, the folk art of painting Easter eggs. Every region, even village, has hundreds of distinct patterns, each with a special meaning and ritual, but not all participants are inspired by traditional designs.

"Second generation Ukrainians are reluctant to go back. It's a shame, but we're looking at it materially. Because of the economic situation they won't consider moving back."

"It isn't easy for the young people, they haven't seen the Ukraine, although they hear from their parents 'Oh, it's a beautiful country . . .'"

"I told my children when they were right small. If you don't write to me in Ukrainian, I don't know you. They're still writing to me in Ukrainian."

Watching traditional folk dancers at the summer camp held in Weston-on Trent, 1996.

"We were brought up in this wonderful community that was alive with dancing. Every three weeks of the year we were sent to the Ukrainian camp to revitalise the Ukrainian in us. But I would come back from there feeling very, very confused because I felt I didn't really belong at the camp, and I'd go back to school and I wouldn't fit in there either. I started resenting the English people I was around and I felt like an orphan. I think a lot of people do in terms of where they belong."

"Our parents were born in the '20s, we were born in the '60s. We didn't have anybody born in the '40s. The age gap – it was a psychological minefield you know. There was a big educational gap. They only had four or five classes, we all became professionals. There was no trading generation in between. They were completely different people, brought up differently, not understanding and yet wanting to understand. It was only when I [went to Ukraine] I can understand why they were like they were."

54

Zdorov, the English language magazine for young Ukrainians, holds its annual Christmas ball at the club in Manchester, 1996.

"There's so much I should tell my mother but I can't. You want to say 'Being Ukrainian is crap sometimes, why did you even bother with it, why didn't you integrate more?' I used to be so embarrassed taking people home, because we didn't have an English looking house. The furniture was different, the relics and the icons and the embroidery were all up, and everything looked old fashioned to me. I didn't want to bring my friends back. When I went to their houses it was all formica surfaces."

"You couldn't invite your English friends to the Ukrainian club without feeling awkward. Your Ukrainian friends didn't really mix with your English friends either. It felt like you led two separate lives, and for a child that was quite a big thing to do."

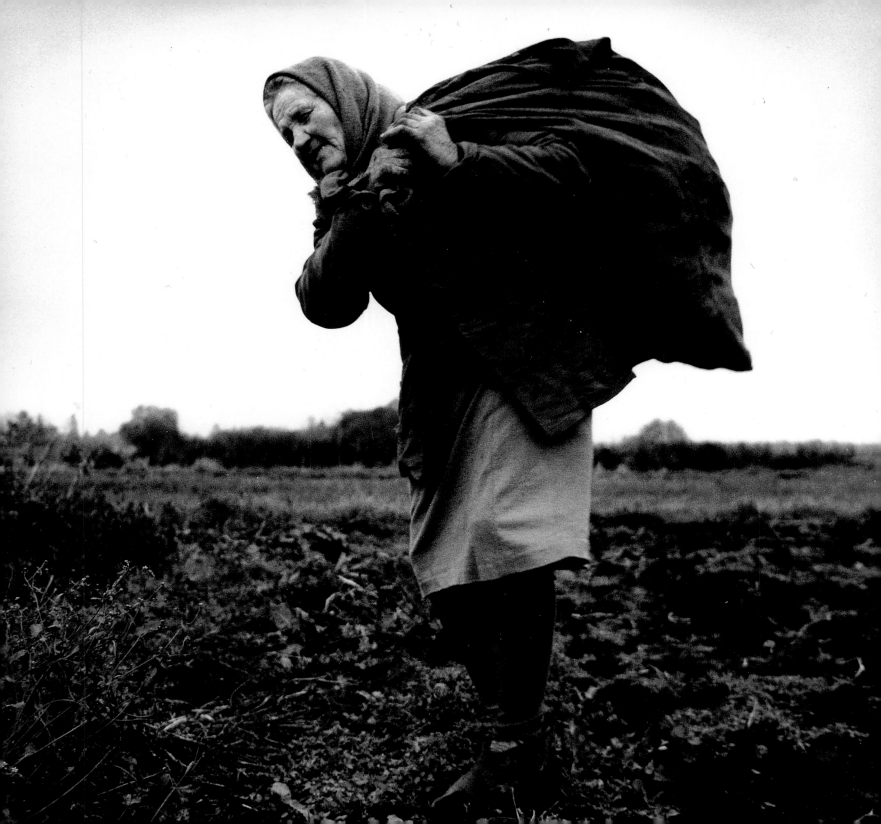

STAYING: THE ROAD TO INDEPENDENCE

At the end of the Second World War the Soviet authorities asserted their prewar policies to the whole of Ukraine. The process of collectivisation was completed in Western Ukraine and peasants were forced to join the collective farms, or executed or deported. Some went into hiding in the dense forests of the Carpathian mountains and joined the UPA guerilla army which continued a desperate struggle into the 1950s. Relying on the support of most of the population, they would carry out raids on Soviet installations and personnel. The NKVD responded with a programme of searches and arrests and pursued a campaign to crush nationalist feeling once and for all. UPA members had a bounty on their heads and if caught were frequently tortured and shot. Rather than be captured some committed suicide and a romantic myth has grown up around these dogged and brave fighters which helped to sustain nationalist feeling long after the last UPA members had been rounded up. Stepan Bandera, leader of the Organisation of Ukrainian Nationalists, lived in exile in West Germany where he was assassinated by the Soviet Security Police in 1959.

In all half a million people were deported to the labour and prison camps of the gulag during the 1950s, in addition to those banished immediately after the War. Russians were brought in to occupy all key positions in government, industry and education. In 1946 the Ukrainian Catholic Church was outlawed, its leader Archbishop Slipyi exiled, and along with the Ukrainian Orthodox Church, it was forced into union with the state-controlled Russian Orthodox Church. The Ukrainian clergy was decimated by arrests, and religious expression was driven underground. Baptisms, marriages and funerals with any religious content had to continue in secret. Ukrainian language teaching in schools was undermined and Russian became the official language. Speaking the language of the Soviet empire and joining the Ukrainian Communist Party became the route to success and privilege.

Stalin's death in 1953 and Khrushchev's denouncement of his policies in 1956 brought a thaw. Literary works by some leading Ukrainian writers and intellectuals executed in the Great Terror were rehabilitated. Correspondence between Ukraine and the diaspora became more common, although travel remained difficult. During the late 1950s and 1960s there was an upsurge of Ukrainian culture, particularly poetry. This was initially tolerated, as long as it was not what could be deemed 'anti-Soviet'. However the authorities were increasingly alarmed by cultural figures, historians, journalists and those who led protests against what they saw as subjugation of their nation, and in 1965 and later in the 'General Pogrom' of 1972, thousands were imprisoned in labour camps for 'anti-Soviet agitation', or sent for indefinite periods to psychiatric hospitals. Once again, organised dissent was driven completely underground and did not re-emerge until the 1980s.

The explosion at the nuclear power station at Chernobyl near Kiev in April 1986 dramatised how far the Soviet system was in decay. Reports of abnormally high levels of radiation from Sweden, Denmark and Finland were initially played down by Soviet scientists. The scale of the disaster soon became obvious as did the inability of the government to act decisively, and it became a focus for opposition to Soviet rule. Chernobyl was followed by a much broader policy of glasnost, or openness, and perestroika, which meant restructuring and change in all fields of Soviet life in step with the new policies being introduced by Gorbachev. They included decentralisation, popular representation, freedom of speech and access to information.

In 1987 many 'prisoners of conscience' were released. Former 'dissidents' were able to initiate public debate on issues concerning Soviet society and began to reveal the truth about Soviet power. In 1988 the Ukrainian Catholic Church used celebrations marking one thousand years of Christianity in Ukraine to emerge

elderly woman village near tomir ecting food for forthcoming ter. Formerly ember of the ective farm, now tends own land.

57

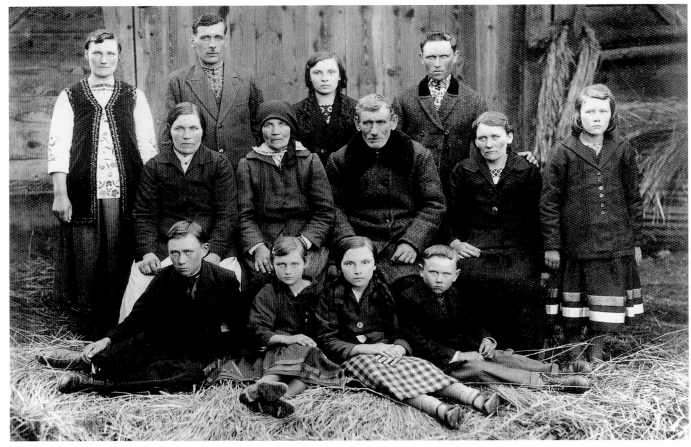

A kulak, or rich peasant family, at a harvest festival celebration in Galicia. In 1947, during the drive to complete collectivisation in Western Ukraine, all members of this family who had not fled to the West were sent to Siberia.

BHRU archive

"I was born in the Arctic Circle, part of a politically repressed family. My father worked in the underground and in 1950 Stalin sent him to Siberia. Born in 1960 I lived in Siberia for the first ten years of my life, going to a school of seventeen different nationalities. The Baltic states, Moldavians, the Caucasus states, Central Asia, Russians, Eskimos, people were sent from all over the Soviet Union to this mine in the Arctic waste. A desert of snow. Winter nine months a year. A small village with five or ten thousand people around the mine, this was the whole world to me as a child. But my parents told me stories, and in school Communist propaganda told me another story, all mixed up in my head."

from its position as the largest underground church in the world, with four million members. As they marched through Lviv and took over churches, nationalists held rallies in the city demanding independence. Following a big ecological rally in Kiev the Popular Front was established, also known as Rukh. They called for 'genuine sovereignty for Ukraine', freedom of worship, the full range of human rights, the creation of a market economy, and the granting of the status of state language to Ukrainian. As members of a Democratic Bloc they took part in the local elections of March 1990. They performed poorly in the Crimea and Eastern Ukraine, but did well in other areas of the country, gaining control of the city councils of Kiev and Lviv.

Their success and the nationalist celebrations which followed encouraged the coming together of some of those in the Communist Party with members of Rukh. As further revelations about damage as a result of Chernobyl emerged and the economy worsened those who continued to be loyal to Moscow grew ever more isolated, particularly after a series of damaging strikes by miners in the Donbass region. As it became clear Russia itself was an economic disaster zone, even many of those in the staunchly Russified east began to consider that their future might be more secure with an independent Ukraine, even if they did fear the anti-Russian nationalism represented by some of the more chauvinistic members of the new political parties.

As a result, by July 1990 the Ukrainian parliament was voting for Ukraine's sovereignty and for the country to become a neutral state. Shortly after the abortive hardline Soviet coup in Moscow in August 1991, the Communist Party of Ukraine was banned. Independence was declared pending a national referendum the following December, when 84% of the population came out to vote overwhelmingly (90%) in favour of independence.

When the photographs and interviews contained in this chapter were collected in the autumn of 1991, collective farming was at the point of collapse. Young people had flocked to the towns for better paid work in factories, which were themselves desperately overstaffed, inefficient and obsolete. With fewer people to work the land and appalling distribution and communication problems, caused by a lack of modern expertise and insufficient money to buy spare parts, there were food shortages. Many older people were left to fend for themselves at a time when their meagre pensions were undermined by rampant inflation. On the back of promises of a Western-style consumer culture, political change was swift, and the footwork of members of the outlawed Communist Party even swifter. Many of the old party bosses retained their former positions unchallenged, particularly in the east and in rural areas, and progress for reform on the ground was slow. Outside the nationalist heartland of Western Ukraine the teaching of Soviet history and literature persisted, Lenin's face still adorned the classroom walls, and Russian remained the language of everyday use.

With the legalisation of Ukrainian Orthodox and Ukrainian Catholic churches enthusiastic congregations engulfed weekend services, but there was little money for renovation of churches left derelict for over 40 years. The Russian Orthodox Church, run from Moscow, was reluctant to yield up the property awarded it for complying with Soviet rule. A new religious openness was marred by bitter religious conflict. This was symbolic of a nation being reborn: no birth is painless.

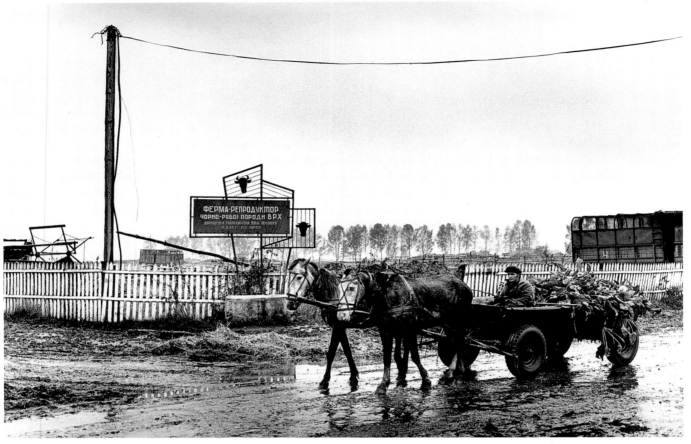

Kolkhoz, or collective farm, to which people were forcibly recruited. Village of Barushkovtsi, near Zhitomir. As the Communist system collapsed in the early 1990s food shortages were particularly severe as people abandoned the collective farms to tend their own land and feed their own families.

"People joined the Party to get a better job, a lighter job as long as it wasn't in the fields. My daughter was in the village council and she joined the Party and now she's got a nice house and everything."

"There are hardly any young people here in the village; they finish their tenth grade and they're off. Maybe they go to the polytechnic. One girl married someone here so she stayed but most of them leave to work in the factories."

"This is the opinion of a simple worker, if you talk to the head of the kolkhoz they would give you a different story. The fields are empty, there are no wages, so no interest in working. There's no money to repair the machinery and anyway we couldn't afford the petrol. This is not living, it's existing."

As peasants began to sell food in the recently opened private markets shortages of even basic items became acute in towns and cities. Prices were far beyond the majority of people who had to queue for hours at poorly supplied state subsidised shops. This is a queue for cabbages in Slavsko near Lviv.

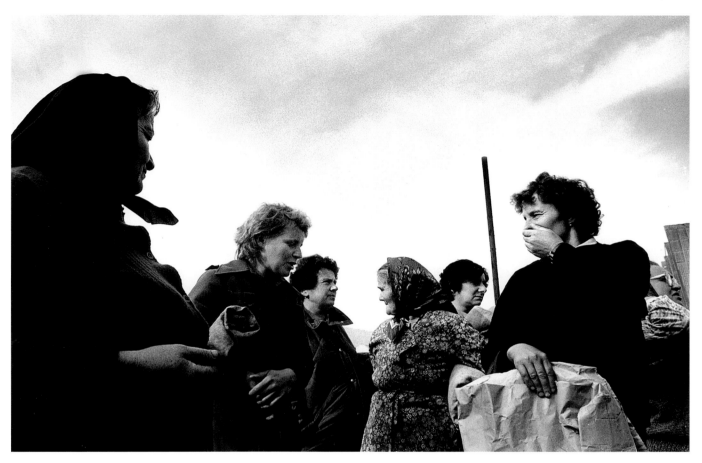

"Women do have to work hard and stand in queues. My grandfather is a veteran of World War Two and has the right to go and get, for example, milk, without queueing. But he always wants me to go to the shop and I said 'But for you it's just a matter of five minutes, I have to spend an hour in that queue . . .' It is tradition, prejudice, the result of the old conviction that the man is the lord of the house, he supports the family."

"We produce one third more food than we use but we lose 40 per cent in the process of production. If only we could organise systems for preserving and transporting food it would solve the problem quickly, and guarantee the export of food."

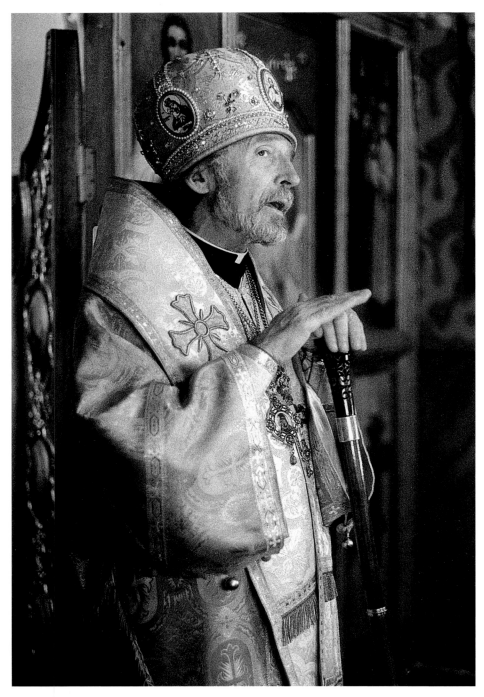

Wasyl Romaniuk, who spent over twenty years in Siberian labour camps for his membership of the clergy, returns to Kiev to lead a service in a newly re-opened church. He later went on to become the Patriarch (leader) of the Ukrainian Orthodox Church.

"I read a lot of religious literature and used to go to church to listen to sermons quite often. This formed my opinions. But then Soviet power came in 1939. I did not have clearly defined beliefs but I was a religious person, it was more a romantic feeling towards poor and suffering people. At the same time surroundings mean a lot to a young person and if he sees that there's no national culture, that their language is despised both by Poles and then by Bolsheviks, and that their national religion is despised, then it provokes inner protest. There were people from the NKVD and local Communist agents. Although I didn't do anything, they said I was a member of OUN. I was sentenced to twenty years of penal servitude as an OUN member. If you were a normal criminal you would be jailed but your family would be intact. If you were a political prisoner your family were immediately exiled, and this happened to my family."

Cow-herder reading a bible, Carpathian Mountains. During Stalin's rule possession of a bible was punishable by deportation to the gulags. Miniature bibles were printed in the West and smuggled into Ukraine.

"Legalisation that seemed like a dream or a fantasy is today a living reality."

"Samizdat is where people would put their writings together and then they would be hand-copied and passed round. Then they would be smuggled out and here in the West we'd have them published. I can remember packing up books sending them off to Ukraine, very small books. They were about two inches in length and perhaps an inch wide, because the smaller it was the easier it was to get it through. It was very, very difficult. Anybody who was going there on business would be asked to take things through, or people would walk across the border."

St. Mikolai is the main Ukrainian Orthodox church in Kiev. Closed for over 40 years, parts of it were re-opened in 1992 for services while the rest underwent restoration.

"Since the [Moscow] coup people can be quite open about their faith: they know they're not going to lose their job. But I wouldn't say we have religious freedom because [the churches] we have still belong to the state. We can't develop our faith because we can't buy any buildings."

"We have great financial problems. We don't basically have any property. We don't have big churches, just chapels, and we faced a lot of obstacles even in establishing those. Probably now it will change for the better but I haven't seen any changes as yet. I live in an hotel, bad as it is, and the whole church is in a similar state."

A mass baptism being held in the Church of the Transfiguration in Lviv. Until recently the four million Catholics of the Ukraine formed the largest underground church in the world. In 1989 they held their first public mass since 1946 in this church.

"The Ukrainian Catholic Church was one of the victims of Stalinism. Martyrdom of its bishops and priests, deportations, arrests and the closure of churches and monasteries. From 1946 churches were turned into barns, cinemas, warehouses, or handed over to the Russian Orthodox Church."

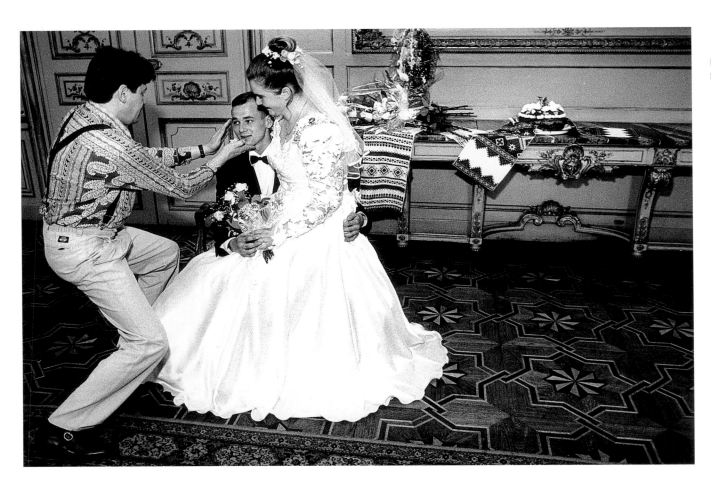

Posing for wedding photographs in Lviv.

"Weddings in church were prohibited, but there were many illegal weddings through the underground church. I never knew of their existence. I was married in winter 1985. The ceremony of civil marriage was very Soviet. We were wished all the best and told we were going to create a firm Soviet family, and you should put flowers at the foot of the monument to Lenin, and the monument in honour of the victory of the Soviet Army in the War. If the flowers were not put before the monuments it would be noted by the KGB. It meant the family would experience ceaseless problems. Personally I think nobody was watching us, it was a Soviet myth, but everyone was afraid of it."

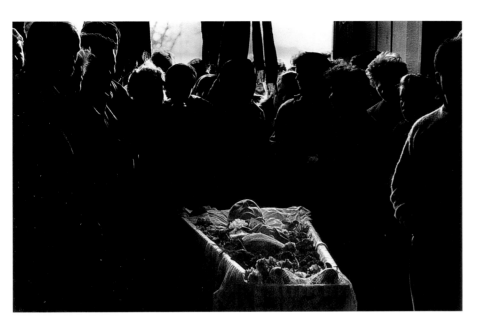

Arrival of the funeral
procession at the
Catholic church.

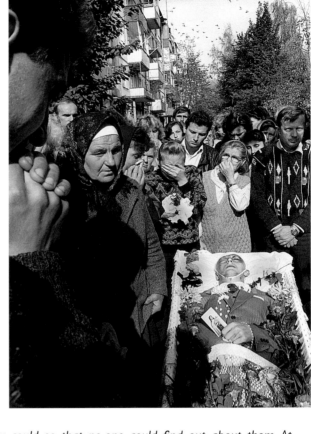

Funeral of a young
man outside his
apartment in Lviv.
The open coffin is
carried from the
home to the church
several miles away.

"Priests tried to do what they could so that no-one could find out about them. At
night-time they would go and minister the sacraments and would teach people and in
the daytime they would go to their work. I did weddings, funerals – it depended on the
circumstances but not so there would be a lot of people around."

"The service took place in the house and then when nobody was there they would go
to the grave. The aim was not to fall into the authorities' hands and to know who you
could work with and who you couldn't. You couldn't call everybody in because some-
body would inform about it and then you're on your way again to the camp ..."

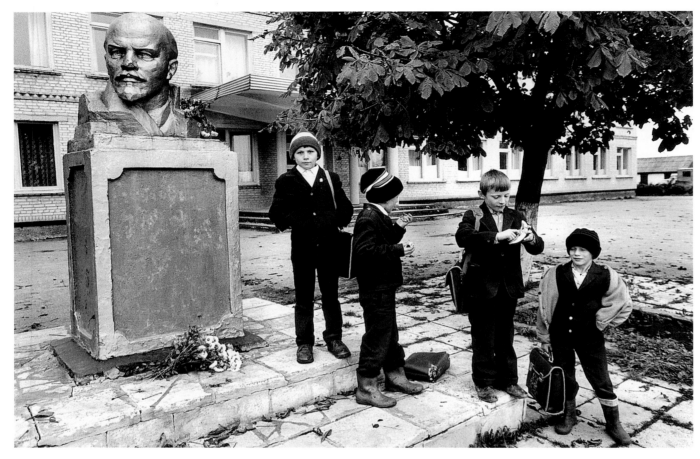

In many areas the statues of Lenin were demolished by 1991 but the one outside the village school of Barushkovtsi near Zhitomir is still decorated with flowers every morning. In rural areas in particular many communities stand by the established order, reflected by an adherence to the Communist curriculum in the classroom.

"Ukrainian history did not exist as a subject of study, there were only a few facts that were allowed to be taught. We had no clear idea of Ukrainian history. We had some kind of notion that was taught us by our parents or grandparents. For the Soviet identity it was very important to stress that Ukrainians as a nation don't have their own developed identity. Just 'Little Russia'. Any small hint that Ukrainians have different stories from Russians was considered extremely subversive."

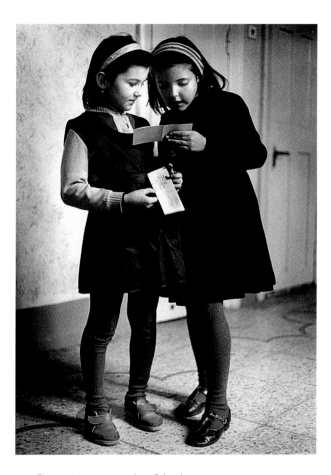

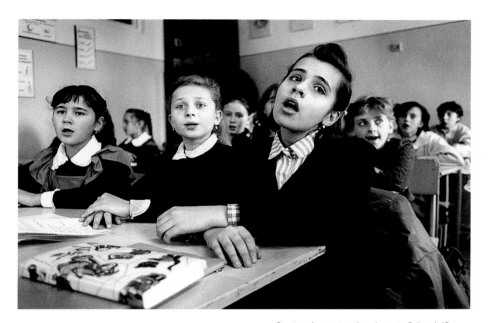

Singing the national anthem in School 62 in Lviv, the heartland of Ukrainian nationalism. This, together with any other Ukrainian music, was previously banned. Having abandoned the Communist curriculum text books are in short supply, partly through lack of money but mainly because many are still to be written.

Comparing report cards in School 62. For the first time since 1944 the children are streamed. They sit termly tests and are graded by results into one of up to eight classes.

"We're learning history again from scratch – we were never taught the kind of history at university that we're teaching the kids now."

"[As a teacher] if I had said the things I tell the kids now I would have been fired."

"For me speaking Ukrainian is very important. I am upset that Ukrainian language is in very bad condition because it's been Russified very badly, even here in Western Ukraine. The fact that in Eastern Ukraine people speak Russian makes me realise that I have to do everything to make my Ukrainian better and teach my kids the language. We must re-awaken an awareness of being Ukrainian in people who forget who they are."

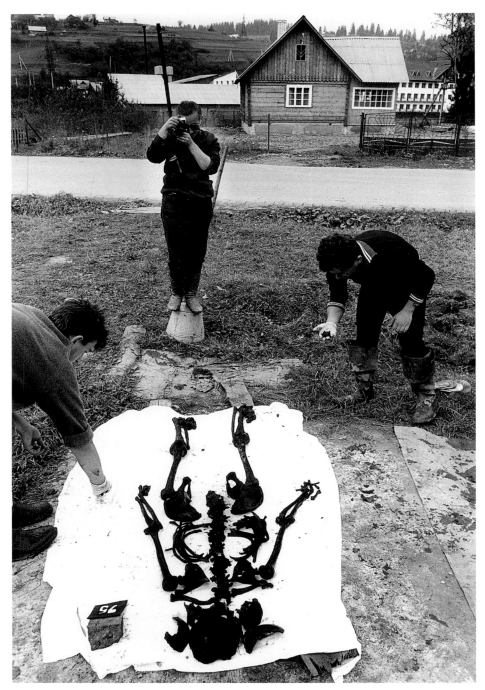

Photographing a newly exhumed skeleton at a mass grave being exhumed by Memorial near Lviv.

"We lead investigations of crimes of the totalitarian system: we do it on a professional level and publish the results in the press and in books. Secondly we make a catalogue of destroyed monuments and works of art. Thirdly we organise exhumations and make symbolic graves ... We also help people find members of their family who were lost in World War Two or were exiled to the Bolsheviks' camps where they disappeared ... We apply to the government to try to find out where they went. So people see our activity and we also publish books of long forgotten Ukrainian authors and this provides money to pay the people who work here."

"People say that there's no need to do the excavations but don't listen to them. People who don't understand say 'Why dig? Just make a grave and put a fence around it'. But others who do understand say the world must know about this ..."

"We open the hole: sometimes there are sixteen, twenty people in one hole. Sometimes it's hard to estimate how many people are there. We photograph the hole and every skeleton is taken out separately. It is washed, photographed again with the number and put in a box."

Against a background of documents gathered from government archives, people queue at the Memorial offices in Lviv for help in claiming the small compensation now due to them as victims of past repressions.

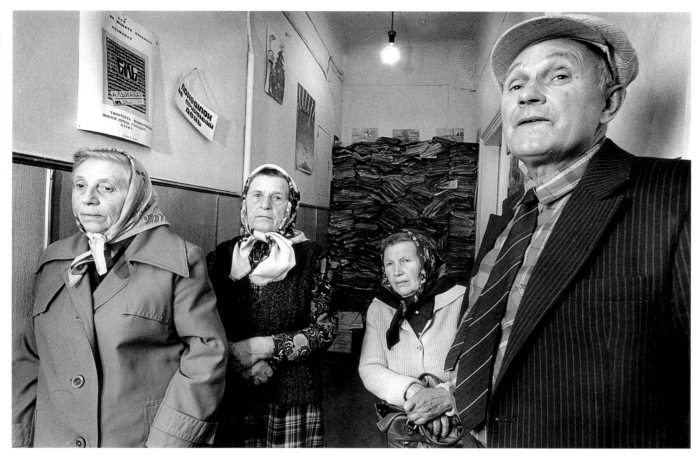

"When Memorial was started in Lviv in 1988 there was an initiating committee of eleven people. Two weeks ago there were 26,000 regular paying members. Memorial is above parties: it is international and we are united by one idea, the struggle against totalitarianism. We are a political organisation but are not a political party. We are not nationalists in the sense of chauvinism: we are against chauvinism and everything connected with it."

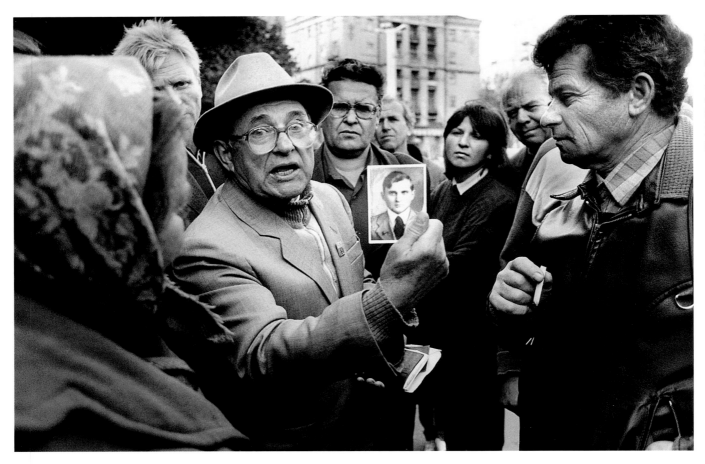

During a political discussion on the streets of Kiev a man makes his point to supporters of the old order by brandishing a picture of himself as a young man, before he was sent to Stalin's labour camps.

"There weren't any religious repressions until 1939 because our territory (Western Ukraine) belonged to Poland. There had been limitations but only political activists were repressed as there were protests against the Polish state. But when Soviet power came in 1939 immediately things started happening like arrests. I was imprisoned in 1944 and spent ten years in the camps. My parents were simple peasants and lived in the village. They were exiled because of me. My father died in Siberia during the exile."

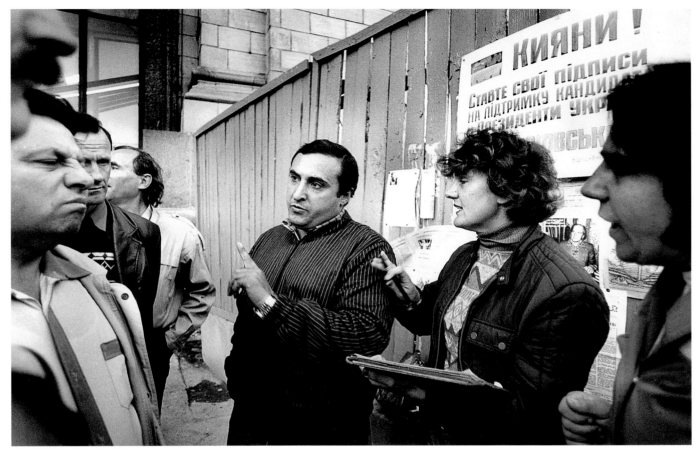

Political lobbying on the streets of Kiev under a sign encouraging people to vote in the forthcoming referendum of December 1991. This overwhelmingly endorsed the declaration of independence made earlier in the year.

"After being so hemmed in for such a long time there was an explosion of political parties and little groups. All of a sudden they were able to say whatever they pleased, they weren't going to get punished for it. So you ended up with so many little factions, but it will begin to pull together into bigger blocks of like-minded. It has to bottom out before it gets better."

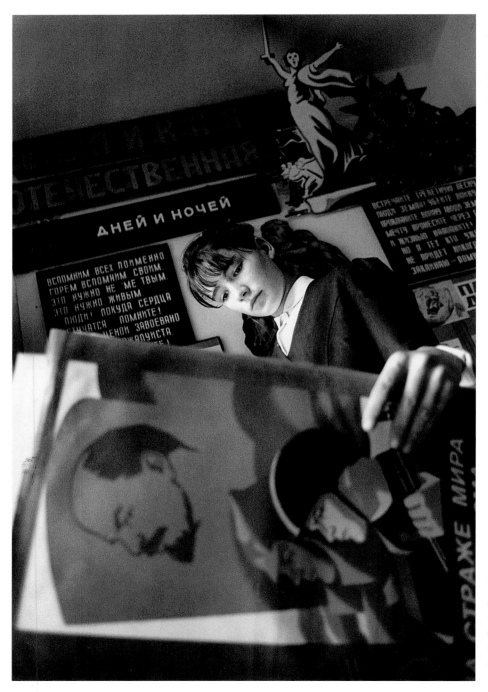

Two rooms of
the school in
Barushkovtsi
are dedicated to
the achievements
of Lenin and
the USSR.

"There has been talk of revising thinking about
Lenin but in this school so far this hasn't come
about. There is no religious education in the
school at all. In the programme of Ukrainian
literature there is a couple of hours devoted to
looking at the bible, but it's very superficial."

Preparing for the demolition of Lenin's statue in the main square of Kiev.

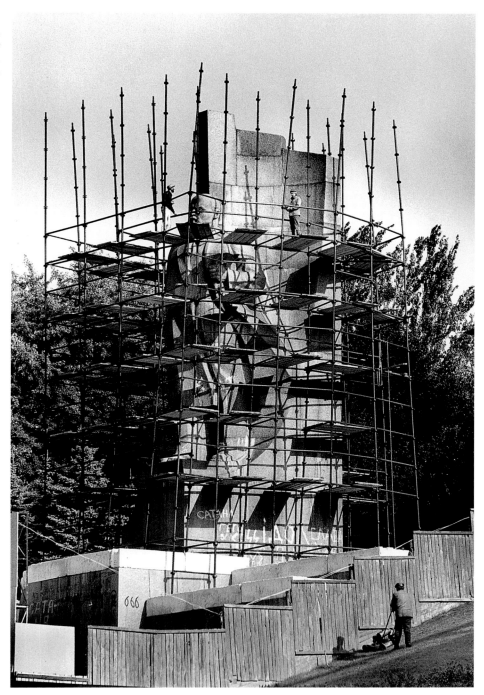

"What is the Ukrainian nation? What is it to be Ukrainian? Most of the Russian-speaking population are not Russians per se. Some are Ukrainians by their identity, some belong to other nations and some are considered not to be Russians nor Ukrainians but Soviets. There is a fighting for their souls, their identity. You need to provide them with some kind of feeling for Ukrainian identity which would be acceptable to them. Now we've made Ukraine, let us make Ukrainians."

"I consider Free Ukraine to be our future. It will be the end of any hunger, any repressions. We will be able to live like people in the West."

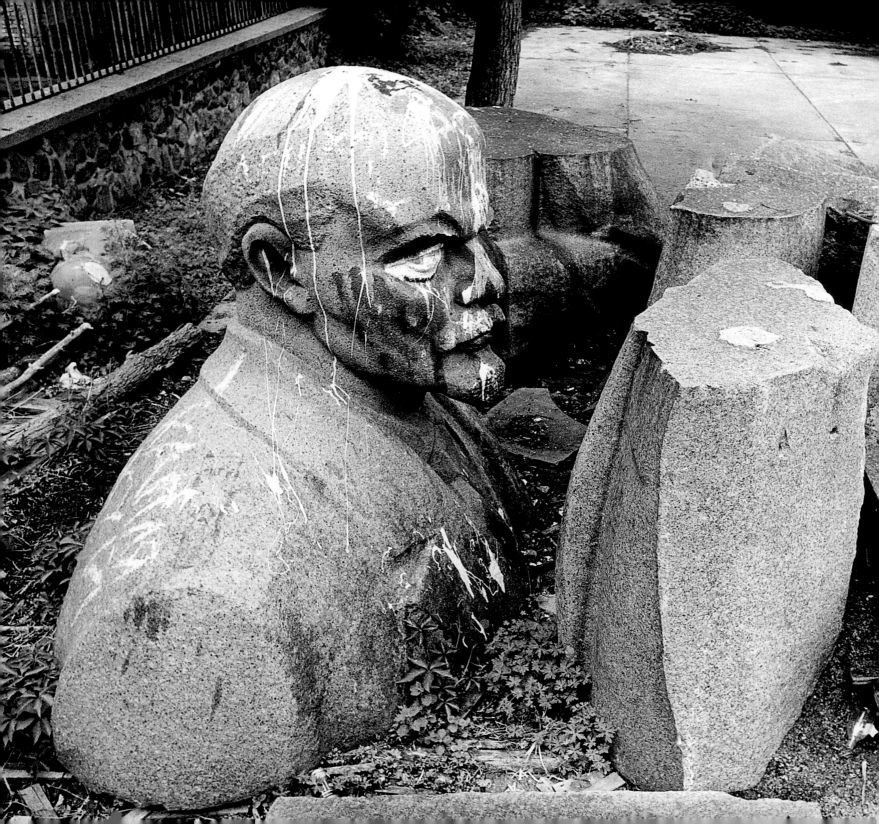

NEW UKRAINE, NEW DIASPORA

With independence the climate of fear created during the Soviet era has lifted. People are free to speak their native languages, to worship in the church of their choice, and to read their native literature. People are rediscovering their nation's history, although it remains a contested history seen from a number of different viewpoints. A disputed past is reflected in the different ideas of what now constitutes the Ukrainian nation. The idealistic nationalism, with Lviv at its centre, that carried Ukraine through independence, has failed to impose itself as the official nationalism. Disillusionment with the new politics has led to a rise in popularity of the Communist Party, re-established in 1993, and has rekindled differences between east and west Ukraine. Although both parts of the country are for the most part committed to national unity, those in the west are more likely to believe that Ukraine's future is in a new Europe. In contrast, many in the east are much more keen to improve, and even re-establish, economic ties with Russia. The presidential election campaign of 1994 was largely fought on these issues, with pro-Russian reformer Leonid Kuchma defeating Ukraine's first president, Leonid Kravchuk. Allegiances were split almost perfectly along the line of the Dnieper River which bisects the country.

As the end of the century approaches, support for democracy in Ukraine remains strong, but the euphoria of 1991 has proved impossible to sustain. Elation has been replaced with the grim realism of a country struggling through the restoration of capitalism. Ukrainians are grappling with the problems arising from the collapse of the old order, and the creation of winners and losers in the new free market system. While many of the old elites have been able to convert their power and influence into new levels of material wealth, the standard of living for the majority of people has deteriorated. As the centralised role of the state has declined large numbers of people have lost their jobs and for many the future has become very uncertain. A large section of those who have remained in employment have only kept their jobs on paper as there is no longer any work for them to do. Even those gainfully employed are not paid for months. This has led to an alternative economy in which the provision of services is often dependent on bribery. Doctors with no incomes are paid directly by patients for health care. The police demand 'fines' for traffic offences. Since no tax is paid on these unofficial incomes the financial problems for the government increase. As pensions remain unpaid for months elderly people without families to support them can be seen selling their few possessions in the markets, or begging outside the glitzy new shops opening in Kiev and Lviv.

Many of the older Ukrainians living abroad chose to remain stateless, and while their children are British, American, Canadian or Australian citizens they, like their parents, have often retained a strong affinity with the homeland. Visits to and from Ukraine which were difficult and infrequent before independence are now common. Many people have made emotional returns to rediscover friends and family they had not seen for over fifty years; others have decided that such journeys would be too painful. For older émigrés the economic problems in Ukraine coupled with lack of health care provision have meant that very few of those who left have returned on a permanent basis. More usual are the younger members of the diaspora who have returned to work in the offices of the multinational firms which have recently moved into Ukraine. Although these organisations offer some new employment opportunities for local people, for the majority of Ukrainians these jobs, and indeed most of the products themselves, remain beyond their reach. As Marlboro Man and Ronald McDonald are emblazoned across dull Soviet housing estates a few of those who have returned from abroad express regrets. If the imagined Ukraine of their childhood has escaped the imposed homogeneity of the Soviet Union, they now fear it being

statue of
n which
herly dominated
main square in
now lies
antled in a
behind the
History
eum.

Nationalist rally under the statue of Taras Shevchenko. A nineteenth century writer, he came to symbolise Ukrainian nationalism, and his figure has replaced that of Lenin all over newly independent Ukraine.

"For the people in Western Ukraine yellow and blue and the national anthem are not just symbols of the new independent era but they are also symbols of their past, of their families. For Eastern Ukrainians they were new, and symbols with a hostile content. It's so difficult to accommodate this old educational baggage with the new reality. I remember first couple of months it was so strange to see a yellow and blue flag on the building of the Oblast [District] Party Committee in Donetsk in 1991. It was quite a shock, because I was educated in this way: these are symbols of the traitors, symbols of the Banderites, symbols of the bourgeois past, nationalism. In Soviet education these were symbols of bad things, forces against the Soviet Ukraine, the Soviet Union. That's why it was strange when these things appeared."

swept aside by the cultural bulldozer of global consumerism.

It would be easy to over-emphasise the impact of the diaspora on the homeland. The vastness of the country ensures that such an influence will remain marginal. Instead, post-independent developments in Ukraine itself are much more likely to shape the future of the communities that exist outside of the country. At one academic conference in 1995 two possible futures were outlined. One was for the diaspora to be an 'in group' of people, whose sense of being Ukrainian is rooted in their own communities rather than the homeland. The second option was for the diaspora to support developments in Ukraine, which includes a mixture of altruism and self-interest. It allows for both aid initiatives and for members of the diaspora to pursue careers that are connected to the homeland. It is this option that has found favour in Britain.

There has been a long history of unofficial and even secret aid to Ukraine. Individuals have been sending parcels of clothes and household goods to their families in Ukraine for many years. This continues to be an important form of practical, and personal, help. Political and religious organisations who sent literature in the past can now operate openly. In addition the organised relief initiatives that began immediately after the Chernobyl disaster have grown. Channels have been established to exchange ideas and skills between institutions in Ukraine and elsewhere. This has included members of the diaspora, such as doctors and teachers, visiting the homeland. New migration from Ukraine was at first welcomed by members of the diaspora. There have been new friendships and even marriages. Worries have, however, been expressed about the different values and expectations that have resulted from the economic disparity between homeland and diaspora. Tensions have developed as cultural differences have become clear and both sides will need to work hard to break down some of the barriers that exist.

While expensive Western goods are relatively easy to import, it is far harder to change the mentality of people who have known only the Soviet system for most or all of their lives. Real and lasting change in Ukraine will depend on what the country can do for itself. Long-term development depends on young people, and here there are many signs of hope. Young people remain optimistic, and are proving to be remarkably adaptable to the rigours of the new system. For many people real independence lies in the future. A future in which a new generation with new skills and different perspectives has matured to take charge of a new Ukraine.

The Donbass region is the industrial heartland of Ukraine, and Donetsk is its main city. The industrial structure of the different republics of the Soviet Union was highly integrated, and this region has been particularly hard hit by the total collapse of this system.

"Starting from independence, the first three years was a period of big illusions, romantic views of the future of Ukraine. The common understanding was that we were already so exceptional among the Soviet republics that pretty soon we could join a family of civilised nations and become prosperous like any other western European nation. What happened was a period of crisis and stagnation and the result was disillusionment. This was reflected partly in the results of the parliamentary elections of 1994 which brought the left-wing to power."

Miners descend for their shift at Gorky Mine in the middle of Donetsk. The miners retain sufficient economic importance for strikes to be effective in getting their pay only a couple of months behind schedule, whereas many people remain unpaid for far longer.

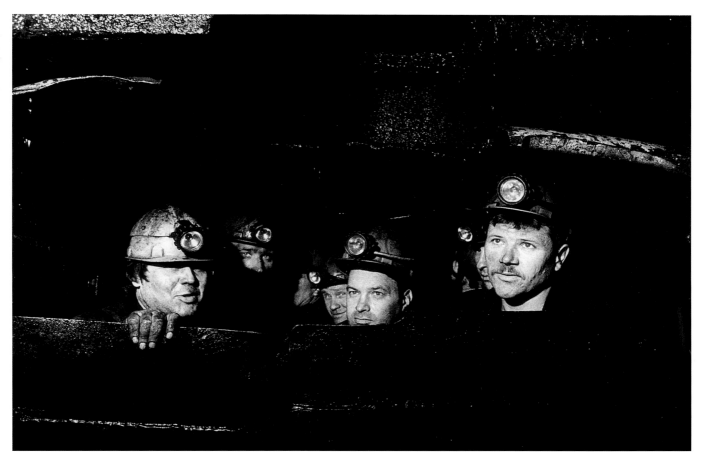

"Under the Soviet system the coal miner was very well paid, perhaps the best paid of all the workers. Now that world has been turned upside down."

"Now the mine has real independence we can have new partnerships, but we have problems with shortages. We should have three times more wood for pit-props than we have. We are very close to stopping work: we have to pay a lot for wood and it's difficult to get. Only this year six miners died. It happened underground when the roof collapsed because the wood we have for pit-props is not very strong ... After the strike of 1989 a lot of people left the mine and now we have problems getting young people to work here."

Empty factory in Ivano-Frankivsk. Formerly a city specialising in the manufacture of sophisticated electronics for the Soviet military, it was for forty years a city closed to outsiders. With the disintegration of the Soviet army most people in the city lost their jobs, and the factories are struggling to adapt to new modes of production.

"There were people in Communist times who were thriving and very loath to let go of their positions. Although we are now supposed to be a free and independent Ukraine the person you see there a year before independence is the person you see a year after. I think it will take at least another generation, because it was so blinkered and closed to the rest of the world that they hadn't seen any other way of running things."

Two young men pass the day in a park in Donetsk. Now that the Soviet army is no longer in existence unemployment is rife in the cities where many used to be employed supplying the armed forces.

"No matter how bad things were in the past complaining could get you into trouble. Whereas now you can complain as much as you like. People are getting bigger expectations, so this is why they're so very disgruntled. But having been so keyed into the economy of Russia for so long, it's not going to happen in a year, or in five years."

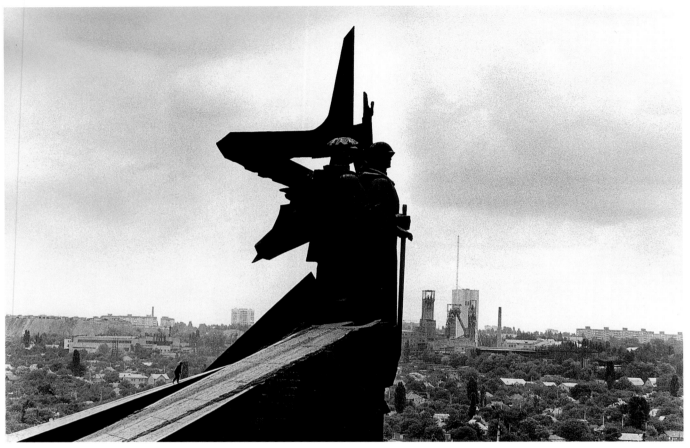

Monument overlooking Donetsk which commemorates the victory of the Soviet Union in The Great Patriotic War. Formerly known as Yuzovka after the Welshman John Hughes who built the first foundries there, the city is dotted with mines, steel works and associated factories.

"Slavery ruins a person from inside and this is the problem here. Especially older people are scared: they don't know what to expect. They lack a sense of security because there is no authority left which they were used to."

"Ukraine's a very big country and there are regional characteristics. I think west Ukraine people are traditionally much more welcoming. In east Ukraine I think people still look on visitors as if they've come from outer space, they've come to spy on us, you know, the old habits. West Ukraine being a lot closer to Europe, they have many more visitors and the personality and the character of people is much more welcoming than it is in east Ukraine."

This construction project was originally intended to result in the headquarters for the KGB in Lviv. It is now earmarked as the main tax office for the city.

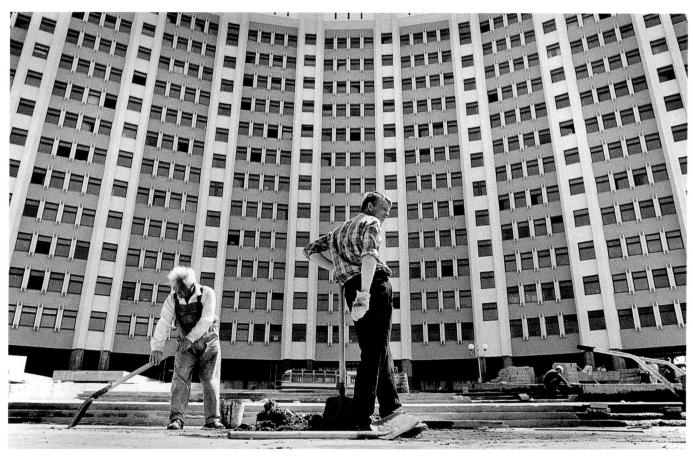

"We've only just started. People don't know how to work. The major problem is that the idea of labour, of work, has been corrupted during the Soviet years because a person feels like a slave and works like a slave. Whereas a free person should work not only to support himself and his family but also to do a good deed, we are all basically slaves in this country. We have to wait for a new generation to come, and bring them up in the proper spirit."

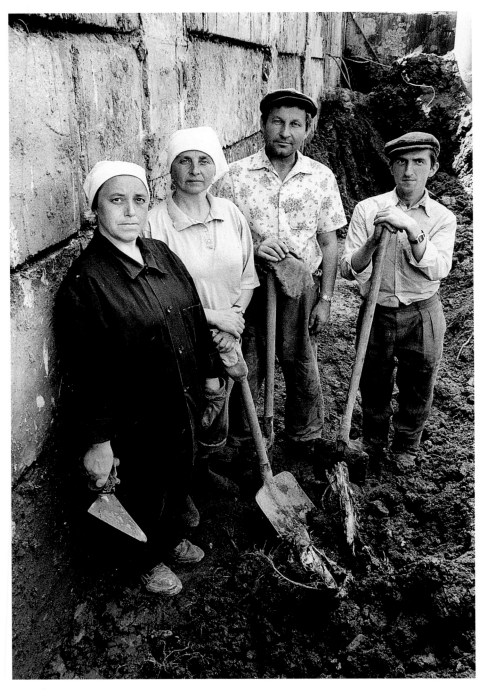

Women employed on building projects are a common sight in Ukraine, such as these working on the foundations of the new tax offices in Lviv.

"Feminism allowed women to work outside the house, to buy the food, come home, clean the house, look after the kids, prepare dinner, look after the husband, go to bed. That's what feminism allowed women to become. Women are so beautiful here, they're stunning looking. But by the time they hit thirty something happens to them. They're worn out."

The 'Barbie Doll Beauty Contest' is held in the main square of Donetsk.

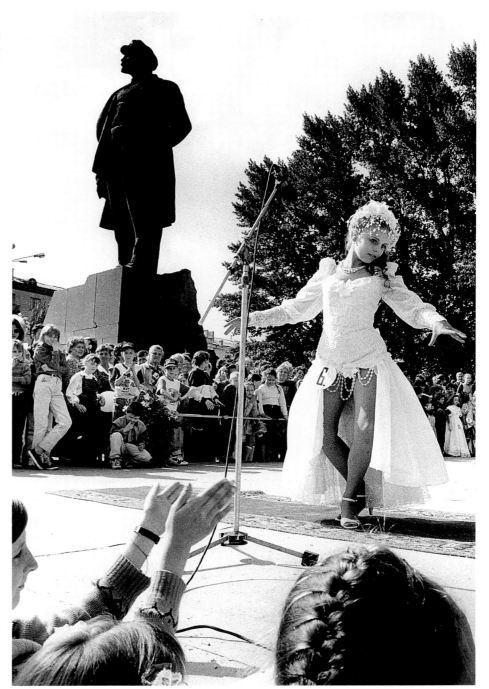

"*Factories, museums, hospitals, schools, everything. A typical example is the director, former Communist Party who doesn't do very much. He's got the big desk — it's always a he — big room, big telephone. The assistant director is the woman and she does all the work. You ask why and that's the way it is.*"

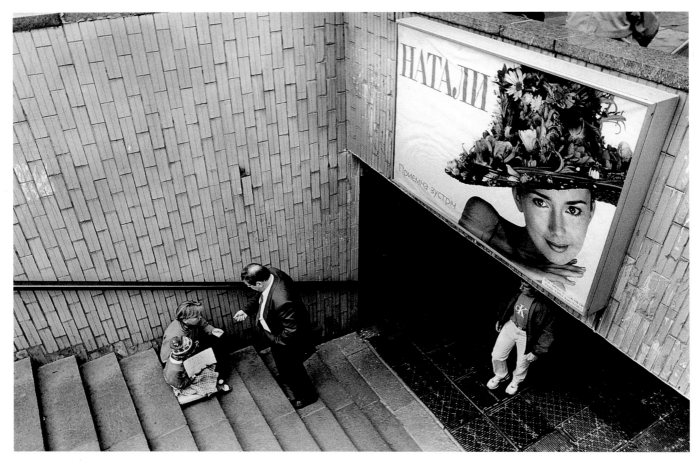

Begging in Kiev under an advert for the launch issue of one of the many new glossy women's magazines.

"One of the main ideas was that as soon as the foreign yoke disappeared Ukraine would be totally European, a totally free people, a very positive image. But after 1991 we see something quite different. Ukraine is not by any standards a Western democratic country, so it gives us a reason for a critical reassessment of our past. Maybe not all of the faults that we were complaining of in the past were made by our enemies. We have some kind of responsibility for it. Before 1991 people tended to be more patriotic; after 1991 the main agenda is to look more critically, to reassess Ukrainian history."

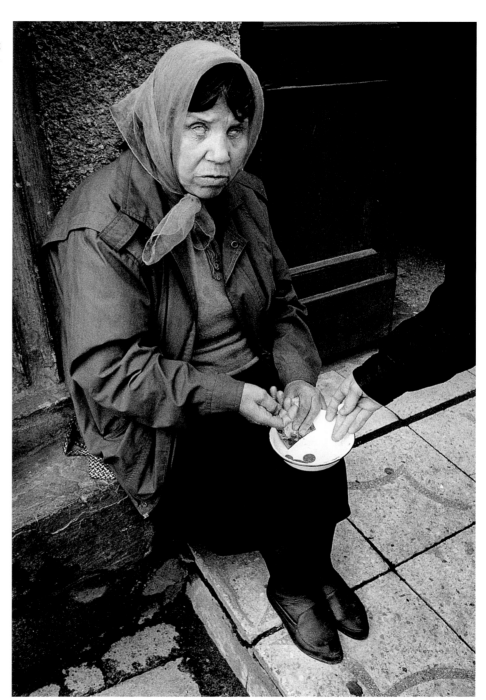

"It's a time of transition and great confusion. There are many people stunned and paralysed, especially those over fifty years old who have lost their job. They have no hope of getting any other. So there are people who are just trying to make do for themselves."

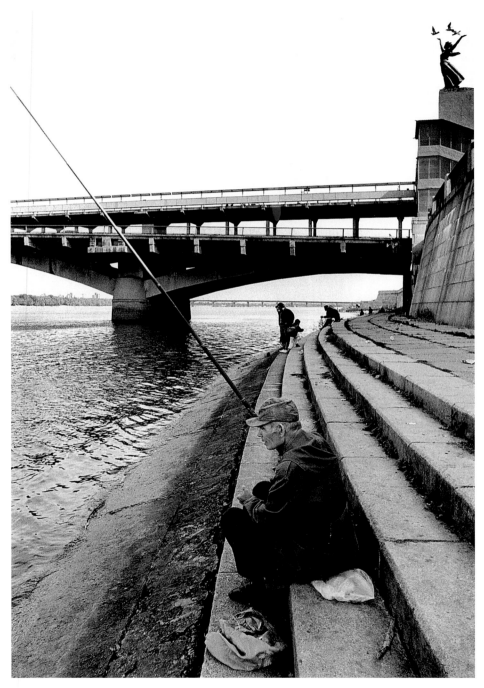

Fishing in the Dnipro River in Kiev. Despite evidence that the water is contaminated by radioactivity further upstream as the river flows through the Chernobyl region, many people rely on fishing as a source of food. Many sell their catch in the markets to generate a small income.

"Ukraine to me was my family. I couldn't see where the beauty was. I could see concrete blocks and I could see tired working people. But parts of it were beautiful, when I saw the river through Kiev, it was massive . . . I was proud to be Ukrainian then."

As people struggle to afford to eat there has been a return to the land, even amongst those who live in the cities. Many travel out to work on smallholdings, such as this woman who lives on the edge of this huge housing scheme in north-eastern Kiev which accommodates 400,000 people.

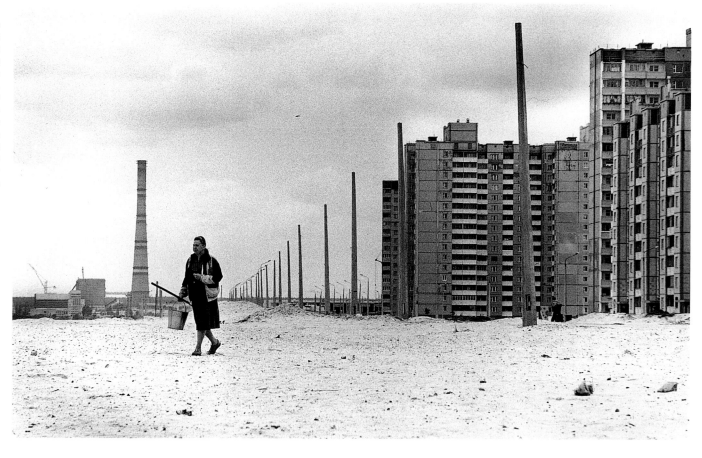

"Is it possible to live on 45 hryvnya [about £15] a month? From this amount you pay for light and gas, and coal for winter, and there's nothing left for food and clothes."

"In the street, in comparison with the West, the foreigner could be struck by the grey faces. But I think our people are more open than the general average Western person. When you go to dinner with them at their house you will see an ocean of hospitality, they will be glad to give you everything they have."

"My parents have a dacha, a building with some land. They are sending us food by train. The family of my friend were living in a two room apartment and when he got married the parents moved to a one room apartment and gave money for a one room apartment for his new family. This kind of help is very popular."

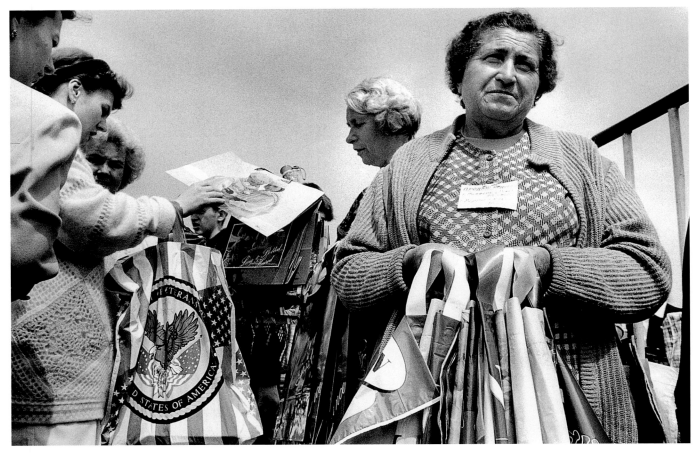

Bag sellers who crowd the entrances to most markets. Although few can afford luxury and usually Western products they advertise, the bags are popular and cheap alternatives to the genuine goods.

"With the older generation, disillusionment is so great, it's really a pity to see old people who have no future in this country. They lost their money because of inflation, the current level of pensions is just nothing, and they don't pay it regularly. So people have to rely on their own abilities to survive, try to use their relatives and their dachas."

"You can tell if someone is from the diaspora immediately. It's the way they talk, the way they walk and the way they dress. And the price goes up accordingly."

Pensioners and a young girl passing Sunday afternoon in the village of Yakovlevka, near Donetsk. In 1997 the monthly pension was approximately £20, but paid months in arrears.

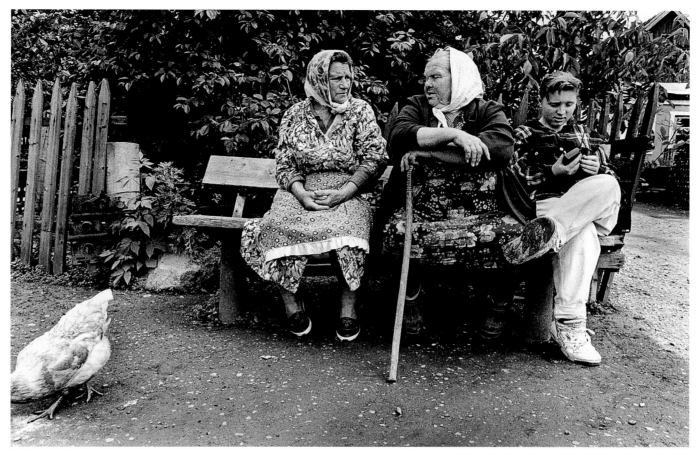

"At least we had some kind of insurance in Soviet times, now we have lost everything. We get by tending our chickens and gardens, and sometimes we go into Donetsk selling eggs. But we haven't seen any butter or sausage here for months. I'm fed up eating potatoes. Thank God it's been raining and our gardens are doing well."

The Monument to Unification of Russia and Ukraine dominates the main park in central Kiev. The archway was known by locals in Soviet times as 'the Russian Yoke'. Rather than demolish it on independence the pragmatic decision has been taken to rename it the 'Rainbow Arch' as a symbol of the unity of all peoples.

"As soon as I got to Kiev [from Britain] the rose-tinted glasses came off: culture-shock. Everybody spoke Russian. Everybody. I couldn't believe it. Lviv, that's the first time that I felt that I'd got to Ukraine. There were Ukrainian flags flying on the town hall, and people spoke Ukrainian in the same accent as my mum and dad. In fact I'd had to double-take about twenty times because I thought I saw my mum and dad walking around, they've all the same physical features down to the headscarf and everything. I feel Kiev is the capital of the state, but Lviv is the capital of Ukraine. Things sort of changed from then. I think the umbilical cord was cut with the community, there was no need to be frozen in the '30s as the diaspora were. I knew that Ukraine wasn't going to disappear overnight, the language wasn't going to die out tomorrow, that I was not the one to keep all this going, so my ties were cut, I was going in a different direction."

Plaque above a subway outside the coal mining headquarters in Donetsk.

"In Lviv we don't have any monuments left. The strength of people's feelings was such that it would have been impossible to preserve any of them. They were all torn down."

"That's not art, it's propaganda!"

"What is Michelangelo about? What is the Statue of David about? That was ideology, propaganda. Social realism, there was something very passionate about it. The coal miner struggling away, he's the hero. That's something unique to this world. I really appreciate it, but [as a Canadian Ukrainian] I didn't have to live with it. People here look at it now and go 'Oh, I don't want to know about it'. They were fed constantly with this stuff and just want to get rid of it. They're destroying a lot of it."

Paintings of 'traditional' Ukrainian scenes on sale in Lviv in front of a new pavement cafe.

"This is something that kills me about the diaspora, and it's something I've always kicked against. I grew up thinking Ukrainian art was houses with Cossacks, guys on horses, sunflowers. And then I started to study art history and learnt there are so many interesting things out there. There was this wild period at the turn of the century. You had Malevich who did Suprematism, abstraction. Could he be called Ukrainian? What does this term Ukrainian mean?"

Souvenirs on sale in Kiev.

"Many people came to the diaspora very traumatised. The simple fact that 17 million Ukrainians were killed this century leads me to think there are a lot of psychological and moral traumas which provoked various coping mechanisms, and the diaspora communities created an intimacy through a common vision. Sometimes that was very far from reality, and holding onto that vision, even though now it's clear that the reality of Ukraine doesn't necessarily coincide, it's a security blanket and it's not surprising that many people don't let go."

Ice creams on sale under plaques erected in Kiev which commemorate the lives of Ukrainian artists, writers and film makers.

"Ukraine's history was forbidden . . . our art and literature has not been allowed to flourish. In ten years things will change."

"I didn't want to go and see this country because I've heard so many stories; so many people have come back [to Britain] so disillusioned. I almost don't want to have my bubble burst thank you very much. Perhaps that's cowardly. Our parents gave us a picture of what they remembered and that is nothing like the reality of today and I don't know if I want to confront it yet. I wonder whether it's a feeling of . . . of being betrayed almost. I suppose that's a bit of a silly thing to say, but the worry is that I'm going to find something that just doesn't match up with my imagination."

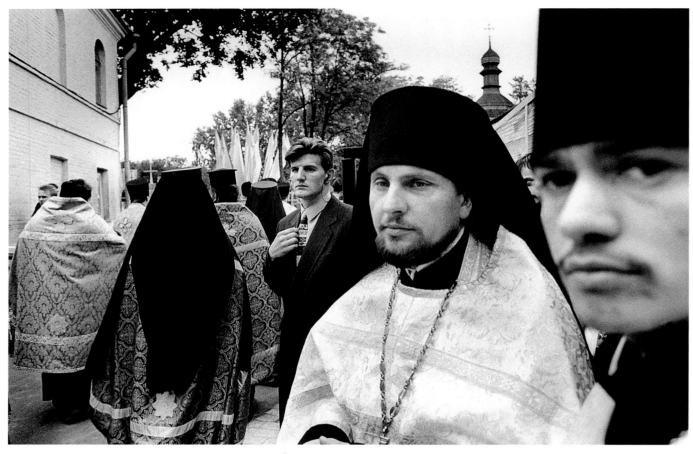

In 1997 a service was held to consecrate the original site of St. Michael's monastery in Kiev, demolished by Stalin during the 1930s. Attended by President Kuchma and his secret service agents, this was seen as an historic acknowledgement by the government of the Ukrainian Orthodox Church. However, many who had clandestinely worshipped at the site for decades were excluded for 'security reasons'.

"Stalin's time, Brezhnev's time, now. Nothing changes. The people who they are letting in for this service are just those in power. The politicians in there are the same people who had the churches destroyed. Those who have worshipped here for years can't get in."

"The authorities always maintained it [St. Sophia Cathedral] had been blown up by the Fascists during the war, but everyone in Kiev knew it was the Soviet army. Telling us such obvious lies meant that people wouldn't believe anything they were told. We live in a society with little trust."

Last minute revision for theological students awaiting exams at St. Andrew's seminary for trainee priests in Kiev. After the decimation of the priesthood during the Soviet era there is a great demand for theological training in Western Ukraine.

"The church here did very well considering what it was up against, but it could not develop its intellectual life. Anything that needed books and texts, they were all confiscated and it could not be fostered."

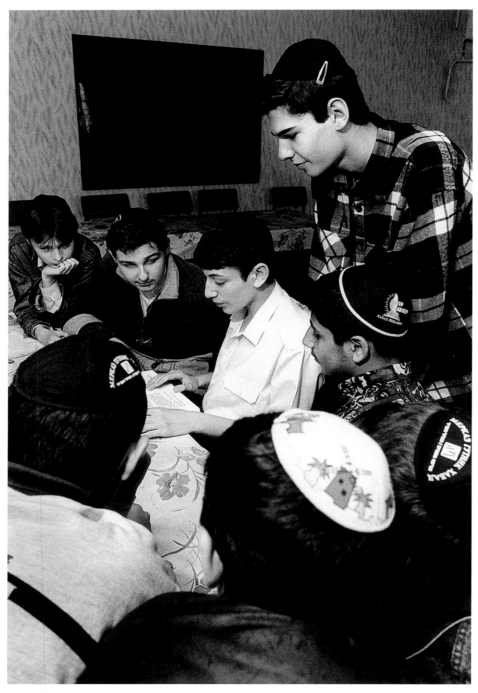

Class for young
Jews at a synagogue
recently reopened
in Donetsk.

"In the 1930s the synagogue was closed and turned into a puppet theatre. In 1989 it was returned to the Jewish community. In the interim religious ceremonies took place in private apartments. We've just opened the first religious school in Donetsk for the past 80 years, and shortly we hope to create all the things that we need to lead our life like a religious community."

Evangelical Christians holding a large outdoor rally in a park in Donetsk. Well organised and funded, numerous religious organisations from overseas have been quick to move into Ukraine, particularly into the East where religion was virtually obliterated under the Soviet regime.

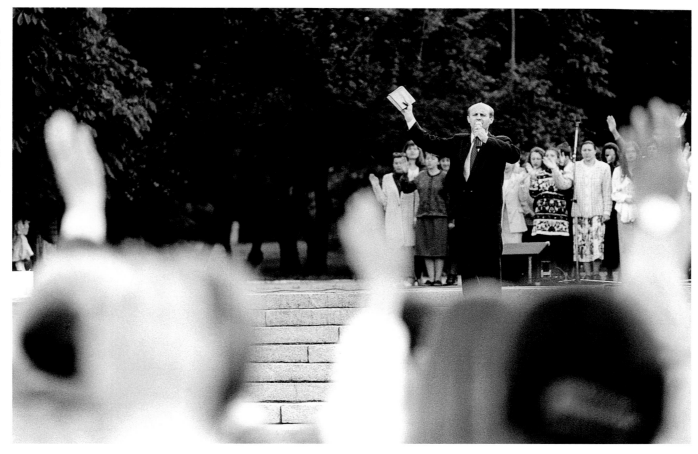

"There are a lot of missionaries, evangelical movements, especially from North America. They're putting out glossy literature and making a pitch that's oblivious to any local tradition, ignoring the fact that there is a thousand year history of Christian church life here. Although it was greatly undermined in the 20th century it can be fostered and revived. They're importing a message incarnated in the culture of Coca-Cola, American influenced, global Western culture. It happens in religion and in other areas. Because of its resources, and because of the devastation that occurred here in Ukraine, that mission just ploughs on in."

Traditional state-run bakery in Donetsk.

"[In 1991] if I wanted to eat it would have to be at the hotel restaurant, there were no other restaurants in Kiev, and service was abysmal – you had to wait half-an-hour before anyone would approach you, even though there was no-one else in the restaurant. If you did complain, people just shrugged their shoulders. People were not being paid a proper wage, so they just couldn't be bothered. Any money they made was made from stealing from the kitchens. You'd look at the menu and it could be three pages long, and everything you'd ask for was 'Niet, niet' – there was only one item available. It really was a shambles. Irrespective of how much you were willing to pay, the only chance you had of a decent meal was at somebody else's house. Now you can buy anything you want in Kiev, Heinz Baked Beans, Cadbury's, Kellog's Cornflakes, but things are very expensive – not everybody can afford them."

‘Manchester’, the first privately-owned shop in Ivano-Frankivsk, is owned by Bob Sopel, a businessman based in Oldham.

"The shop is called 'Manchester'. We're from Manchester. The goods we buy are from Manchester. It's a catchy name, better than Cheetham Hill, that's where we really buy from! Members of my family work there. I brought them to England, to take them to different shops to see the styles, the presentation, the service. If you ever went into a shop in Ukraine you couldn't say 'Show me that on the shelf'. They'd say 'Buy it and you can look at it!' If you asked two questions they'd just put their head down and say 'Finished!'. People just didn't want to work. We had to re-educate them. We wanted to be different, we wanted a Western style business with people smiling. And no speaking Russian, only Ukrainian!"

The cosmetics department at Roxalana, a department store in Kiev famous among those who are doing well in the new economic order.

"The first wave in '91 and '92, certain people who came over I'd classify as carpet-baggers, particularly from America, people who wanted to take advantage of the Ukrainians because they weren't aware of commerce and they weren't streetwise and so on, and they screwed them, defrauded them. As a result of some bad apples a lot of people have been tarred with the same brush. Plus there was still the leftover mentality of the Soviet Union, that if people were coming from the West, they must be a nationalist, they must be a spy. The diaspora had quite a bad name initially. That has changed, well, I'd like to think that things have been forgotten. Now, Ukrainians have seen that many foreigners, it's not a big deal."

Young men outside
a church in the
main square of
Ivano Frankivsk.

"I felt that in Britain some doors would have been closed to me because of my back-ground. It makes me feel 'What if I'd been born here? What kind of person would I have been had I stayed here, been the other half of the village that moved east and not west. What kind of person would I have been?'"

"It's very difficult for people to change their mentality. But with the new generation, they've nothing from the old political system of the last fifty years. I'm an optimist about the future of Ukraine. In the last few years I've seen how it's changed. We'll need to wait another ten or fifteen years but Ukraine will be a healthy country."

The opening
of the first
McDonalds in
Ukraine in 1997
resulted in waiting
times of over an
hour as Kiev
queued for its
first taste of 'fast
food'. By the
year 2000 the
company plans
to have opened
another 85
outlets in
the country.

"There isn't really time to think in Ukraine, many things are happening very quickly, and the rapid Westernisation and departure from local tradition will entail many losses. It will bring positive things, a better standard of living, a more democratic society. The losses may include the role of the family. It was struck many hard blows by the Soviet system, but the nature of relationships between family, and between friends, has a beautiful profundity that I don't think exists in the USA. Another important thing is the attitude towards time. The modern Western person is always in a hurry, just no time. People in Ukraine used to have time, they didn't have many other things, but I think someday it will dawn on many people that suddenly they'll have less time than they did."

Woman in traditional costume on Kiev day, held annually to celebrate the heritage of Ukraine's capital city.

"The three big new factories that have opened here in this town make Coca-Cola, cigarettes and candy. I think we need more than that to live on."

"Ukraine is suffering a severe case of the measles, a rash of red Coca-Cola signs are dotted everywhere."

"Any reality is different from one imagined from a distance. Everyone deals with it in a different way. I adjusted very quickly. The image of a nice cherry orchard, a thatched roof, the nightingales singing, that is not something that haunts me. It was depicted in folk songs and the nostalgic art of the diaspora. I found the real Ukraine with its complex society, its multi-faceted cultural, intellectual, political, social and economic life to be much more interesting than an idyllic imagined homeland that some people are attached to. There are others who are very disenchanted."

Further Reading

Applebaum, A. (1995) Between East and West: across the borderlands of Europe, Macmillan, London.

Boshyk, Y. (1986) Ukraine during World War Two: history and aftermath, Canadian Institute of Ukrainian Studies, Edmonton.

Cesarani, D. (1992) Justice delayed, Heinemann, London.

Conquest, R. (1986) The harvest of sorrow: Soviet Collectivisation and the Terror Famine, Hutchinson, London.

Conquest, R., (1990) The Great Terror: a reassessment, Hutchinson, London.

Dallin, A. (1981) German rule in Russia, 1941-45, Macmillan Press, London.

Hunczak, T. (1993) 'Ukraine during the Second World War', in Krawchenko, B. (1993) (ed.) Ukrainian past, Ukrainian present, Macmillan, Basingstoke.

Herbert, U. (1990) A history of foreign labor in Germany, 1880-1980, The University of Michigan, Michigan.

Homze, E. L. (1967) Foreign labour in Germany, Princetown University Press, Princetown.

Kuzio, T. and Wilson, A. (1994) Ukraine: Perestroika to Independence, Macmillan, London.

Newland, S. J. (1991) Cossacks in the German Army 1941-45, Frank Cass, London.

Pawliczko, A. L. (1994) (ed.) Ukraine and Ukrainians throughout the world: a demographic and sociological guide to the homeland and its diaspora, University of Toronto Press, Toronto.

Perks, R. (1993) 'Ukraine's forbidden history: memory and nationalism', Oral History, 21, 1, pp. 43-53.

Reid, A. (1998) Borderland: a journey through the history of Ukraine, Weidenfeld and Nicolson, London.

Subtelny, O. (1988) Ukraine, a history, University of Toronto Press, Toronto.

Sudoplatov, P. and Sudoplatov, A. (1994) Special tasks: the memoirs of an unwanted witness - a Soviet spymaster, Warner Books, London.

Tannahill, J. A. (1958) European voluntary workers in Britain, Manchester University Press, Manchester.

Ukrainian Cultural and Educational Centre (1992) Harvest of dreams: a centennial celebration of Ukrainian life in Canada, Ukrainian Cultural and Educational Centre, Winnipeg.

Wiesenthal, S. (1967) The murderers amongst us, McGraw Hill, New York.

Oral History Recordings

The original recordings from which the extracts in this book have been drawn are publicly accessible at:

The British Library,
96 Euston Road,
London NW1 2DB
Telephone 0171 412 7440

Bradford Central Library,
Prince's Way,
Bradford BD1 1NN
Telephone 01274 753 661